1987

TERRACOTTA

TERRACOTTA

SCULPTURE BY
BRUNO
LUCCHESI
TEXT AND
PHOTOGRAPHS
BY MARGIT
MALMSTROM

WATSON-GUPTILL PUBLICATIONS/NEW YORK

Copyright © 1977 by Bruno Lucchesi and Margit Malmstrom

First published 1977 in New York by Watson-Guptill Publications,
a division of Billboard Publications, Inc.
1515 Broadway, New York, New York 10036

Library of Congress Cataloging in Publication Data
Lucchesi, Bruno, 1926–
 Terracotta.
 Includes index.
 1. Terracotta sculpture—Technique. I. Malmstrom,
Margit. II. Title.
NB1265.L82 1977 731.4 77-1702
ISBN 0-8230-5320-2

Manufactured in U.S.A.

First Printing, 1977
6 7 8 9/86

The artist dedicates this book to his sons, Carlo and Paul.
The author dedicates it to Bonnie, who stayed out of the way, and Clyde, who didn't.

ACKNOWLEDGMENTS

I'd like to thank: Bella Fishko of the Forum Gallery in New York for making photographs of Lucchesi's work available to me for reproduction in this book; Betsey Greenburg, who graciously gave up her camera for a year while I photographed the demonstration sequences; Judith Baldwin of Baldwin Pottery, Inc., who gave generously of her time and expertise; and Don Holden, who has always known the right questions to ask.

M. M.

CONTENTS

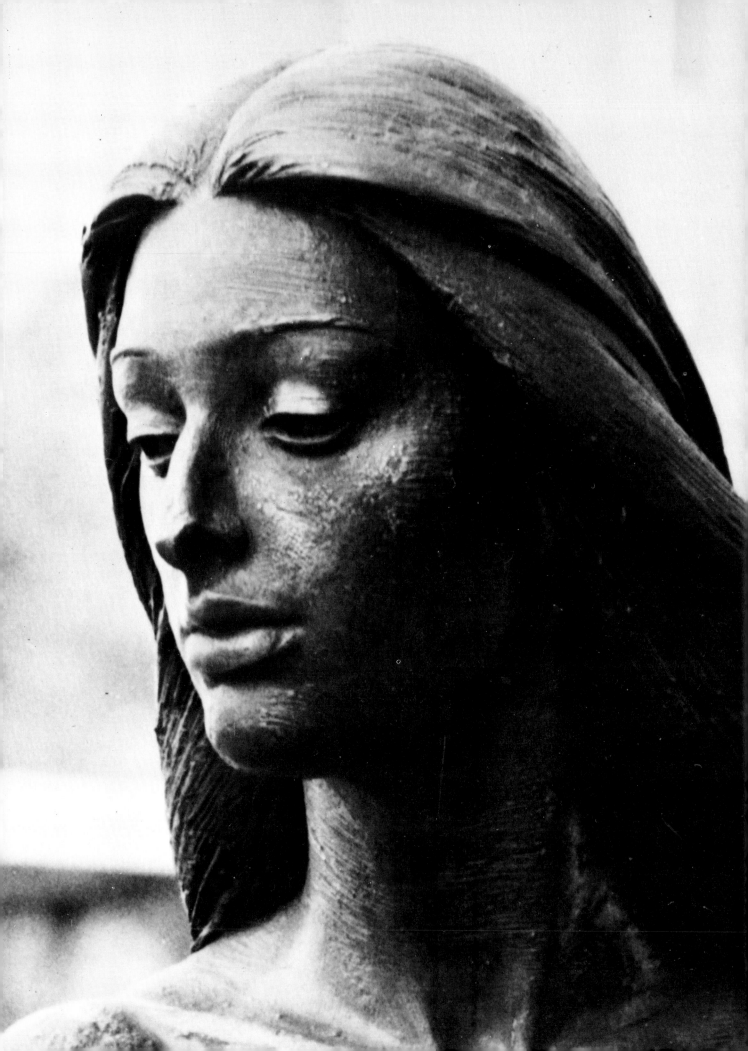

INTRODUCTION

This book grew out of an article I wrote in 1972 for *American Artist* magazine entitled "The Sculpture of Bruno Lucchesi." In it I described briefly some of the techniques Lucchesi uses in making his terracottas. The reaction was a somewhat incredulous, "You mean it's *that* easy?" People couldn't believe that such a basic simplicity of means produced such spectacular results.

The idea of sharing the simplicity of a method that many people assumed was difficult appealed to me. And it appealed to Bruno at about the same time. So day after day he allowed me to follow him around the studio with a camera as he created pieces especially for this book to demonstrate approaches to a number of different problems. One thing that became clear as I watched him work was that although his methods may be uncomplicated, the degree of skill that he brings to them is staggering. And of course that is the one thing no book can give you. The purpose here is to take the mystery and fear out of terracotta sculpture: to show you how to construct a piece so that it will fire successfully and to share studio hints and shortcuts that you would ordinarily only get by working in a sculptor's studio. You'll watch a master sculptor at work; what you get from the experience will depend on what you bring to it. For me, snapping photographs and asking questions, the most important insight I came away with was that art must be approached with courage. Lucchesi doesn't tiptoe around his sculpture tapping it into existence; he asserts himself completely, with his whole body, saying in effect: "*I'm* the boss here!"

ABOUT THE ARTIST

Bruno Lucchesi was born in 1926 in the village of Fibbiano, high in the mountains of Tuscany, in the province of Lucca, Italy. His family, like all the villagers, were farmers and shepherds; they raised the food they ate and made the clothes they wore, and as a boy Bruno took his turn on the steep mountainsides to tend the sheep. But young Lucchesi's artistic gifts were early recognized and he went to study art in Lucca and later in nearby Florence. When not in school, Bruno prowled the streets and museums of Florence and learned by heart the lessons of the greatest masters of Renaissance art. He was especially drawn to the architecture of Brunelleschi and Alberti, the sculpture of Tino di Camaino and Donatello, and the work of the Mannerist painters Pontormo and Il Rosso.

In 1957 Lucchesi came to the United States, where his sculpture was a radical departure from what was being seen at the time. His work springs directly from the nourishing Tuscan soil and the long tradition of Italian Renaissance art. It is realistic, approachable, understandable, and executed with consummate skill. It is beautiful in its grace of line and expression. And, in addition, it has an intimacy and a sense of pathos and humor that are completely contemporary. The excellence of Lucchesi's work was instantly recognized, and over the years his sculptures have been added to the collections of the Whitney Museum of American Art, The Brooklyn Museum, the Dallas Museum of Fine Arts, The John and Mabel Ringling Museum of Art in Sarasota, Florida, and The Pennsylvania Academy of the Fine Arts, among others. His work is also well represented in many private collections, among them the Joseph H. Hirshhorn Collection and the Albert A. List Collection. He has received awards from the National Academy, which elected him Member in 1975, the National Arts Club, and the Architectural League, and he was a Guggenheim Fellow in 1962–63.

Lucchesi is perhaps best known for his smaller figures and his genre sculptures, but he also does many major commissioned pieces that are lifesize and larger. Among these are his heroic-size bust of the poet Walt Whitman, installed in 1971 in Arrow Park, Monroe, New York, and—most recently—a heroic-size statue of Sir Walter Raleigh commissioned by the city of Raleigh, North Carolina, installed in 1976.

Lucchesi lives in New York, where he takes time out from creating new work to teach packed classes at the New School and the National Academy.

The sculpture of Bruno Lucchesi may be seen on permanent display at the Forum Gallery in New York, which has been his exclusive dealer since 1960.

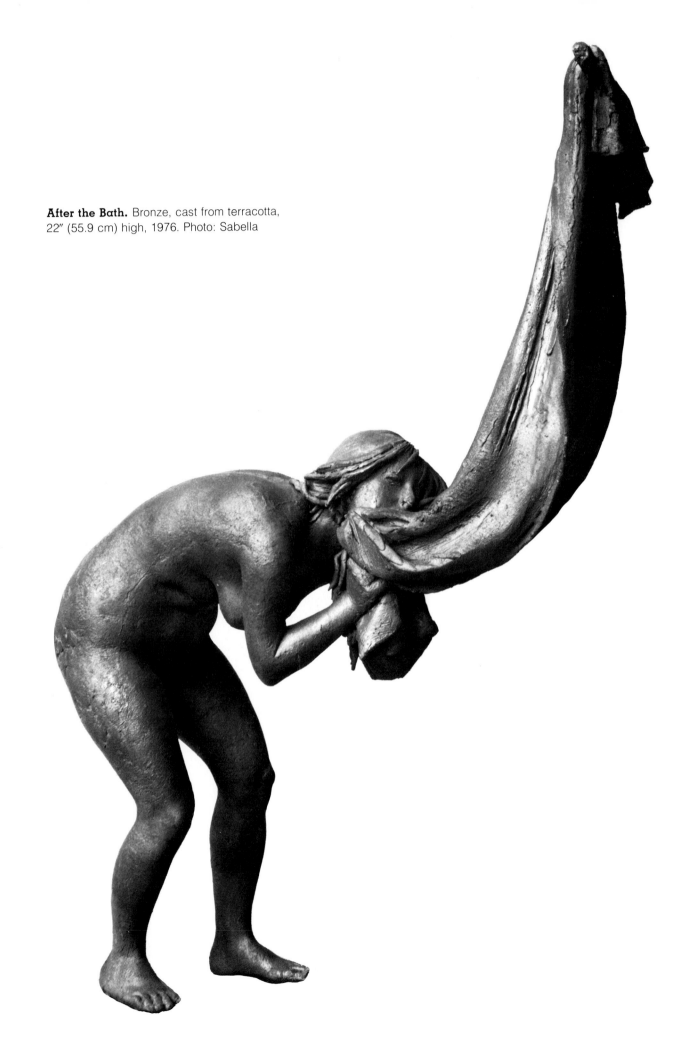

After the Bath. Bronze, cast from terracotta,
22″ (55.9 cm) high, 1976. Photo: Sabella

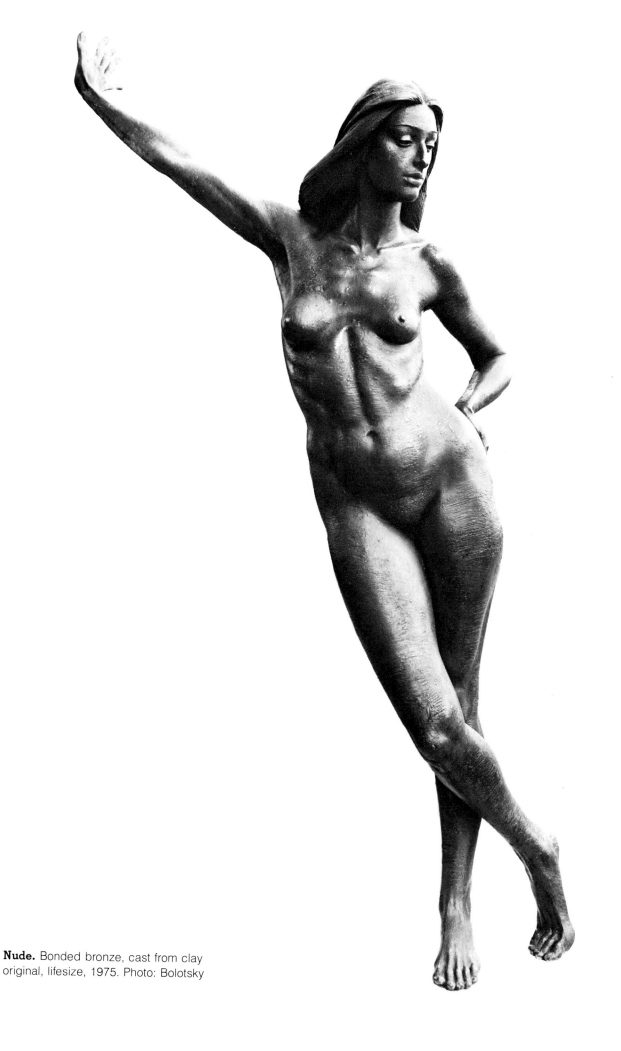

Nude. Bonded bronze, cast from clay
original, lifesize, 1975. Photo: Bolotsky

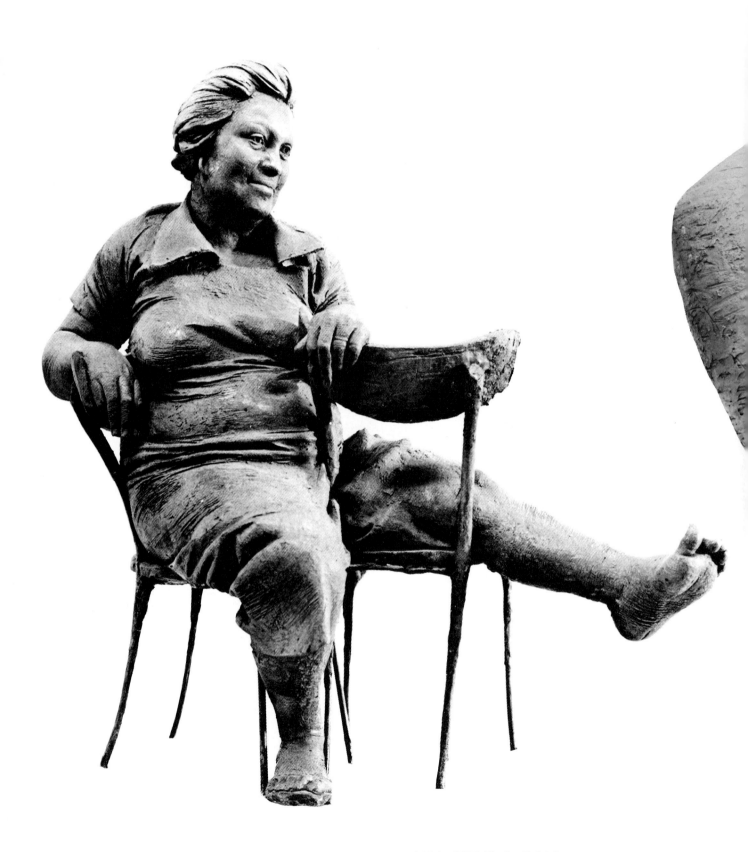

Italian Woman. Terracotta, 18″ (45.7 cm) high, 1974. Photo: Bolotsky

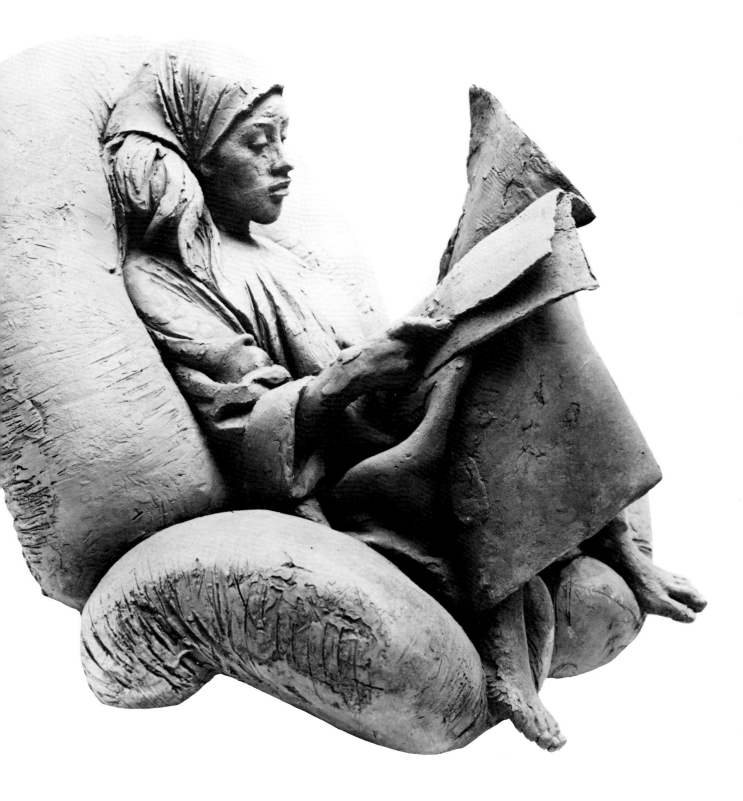

Reading the Paper. Terracotta, 9″ x 12″ (22.9 x 30.5 cm), 1975. Photo: Eeva-Inkeri

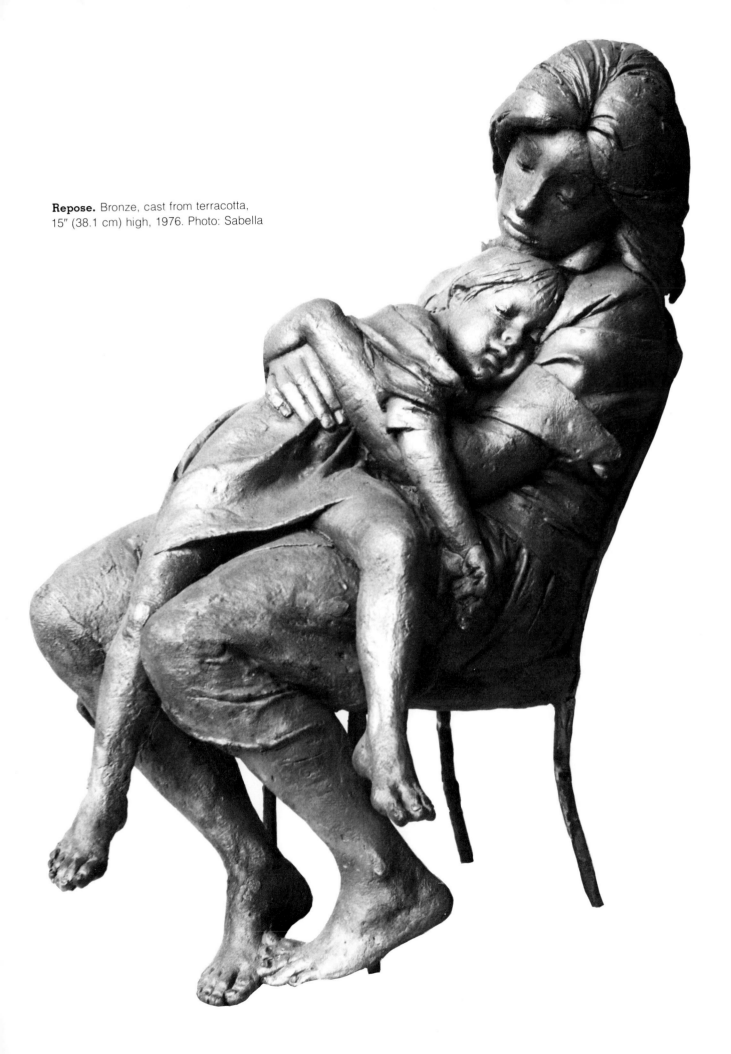

Repose. Bronze, cast from terracotta, 15″ (38.1 cm) high, 1976. Photo: Sabella

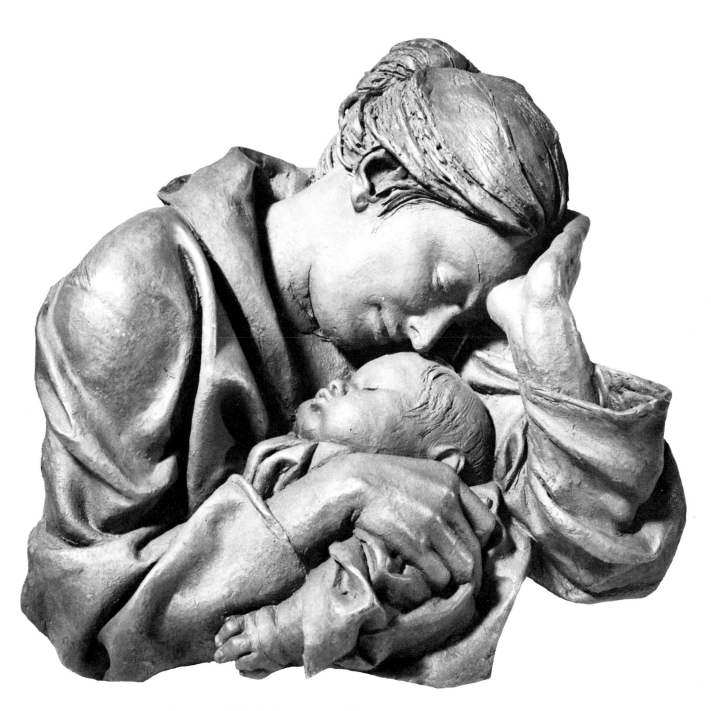

Mother and Child. Terracotta, 15″ (38.1 cm) high, 1974. Photo: Bolotsky

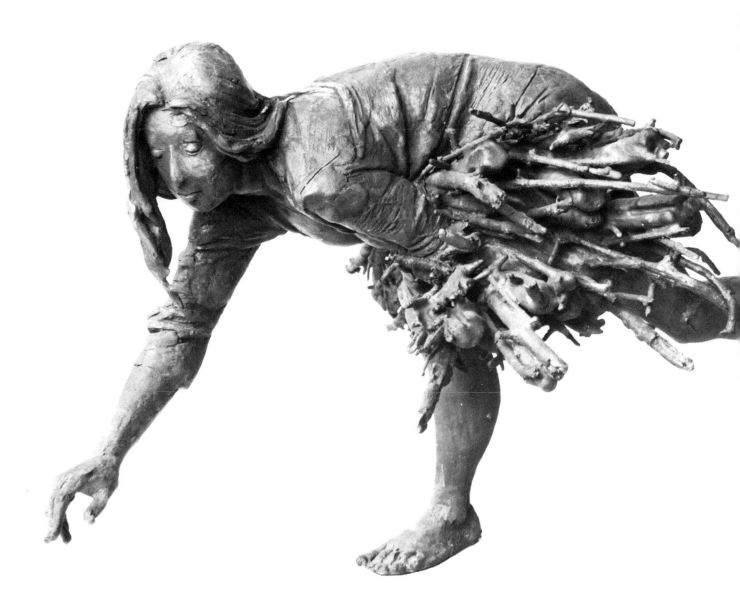

Gathering Firewood. Bronze, cast from terracotta, 18″ (45.7 cm) high, 1976. Photo: Sabella

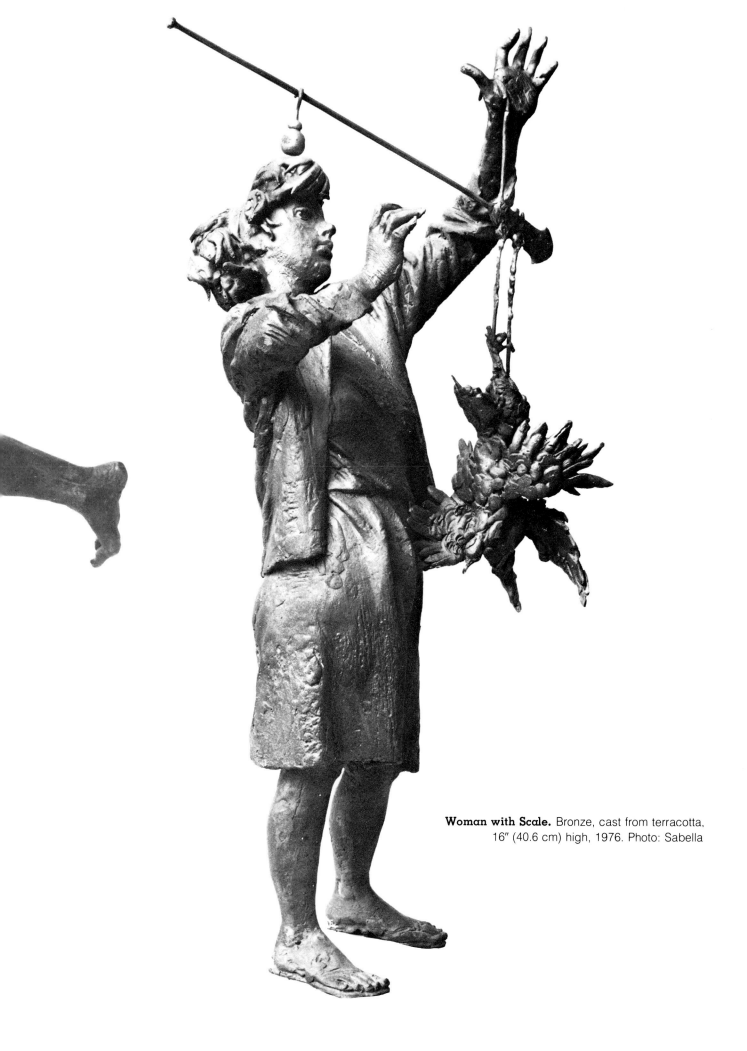

Woman with Scale. Bronze, cast from terracotta, 16″ (40.6 cm) high, 1976. Photo: Sabella

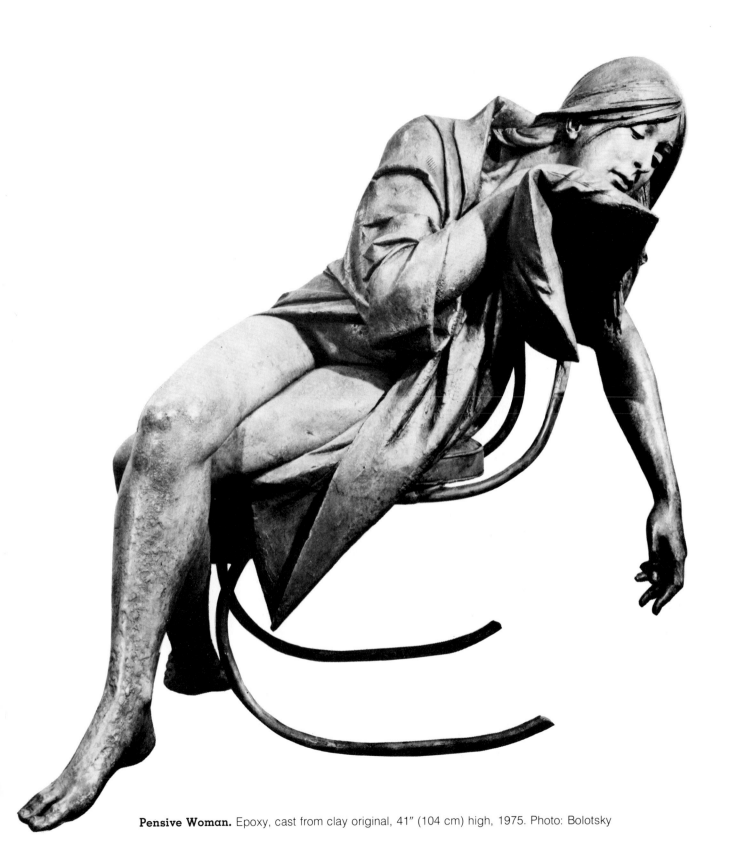

Pensive Woman. Epoxy, cast from clay original, 41″ (104 cm) high, 1975. Photo: Bolotsky

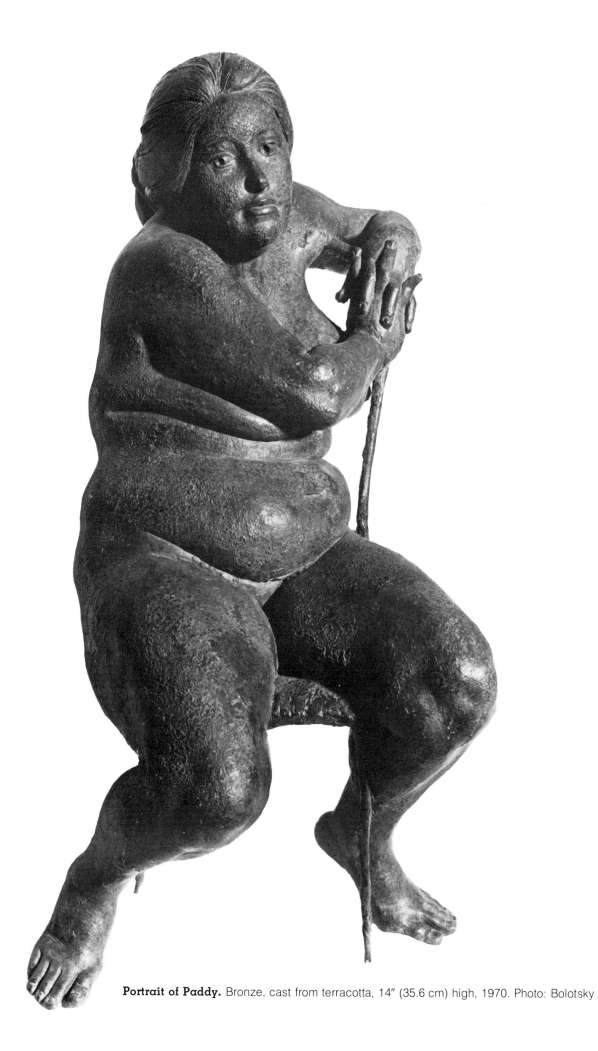

Portrait of Paddy. Bronze, cast from terracotta, 14″ (35.6 cm) high, 1970. Photo: Bolotsky

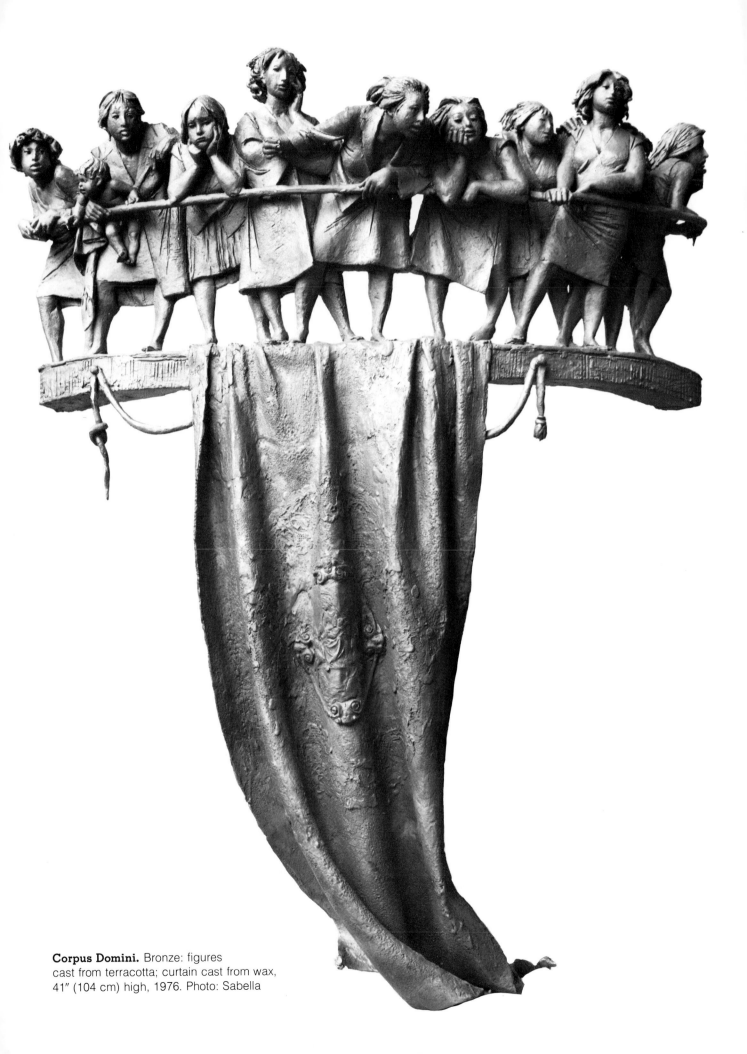

Corpus Domini. Bronze: figures
cast from terracotta; curtain cast from wax,
41″ (104 cm) high, 1976. Photo: Sabella

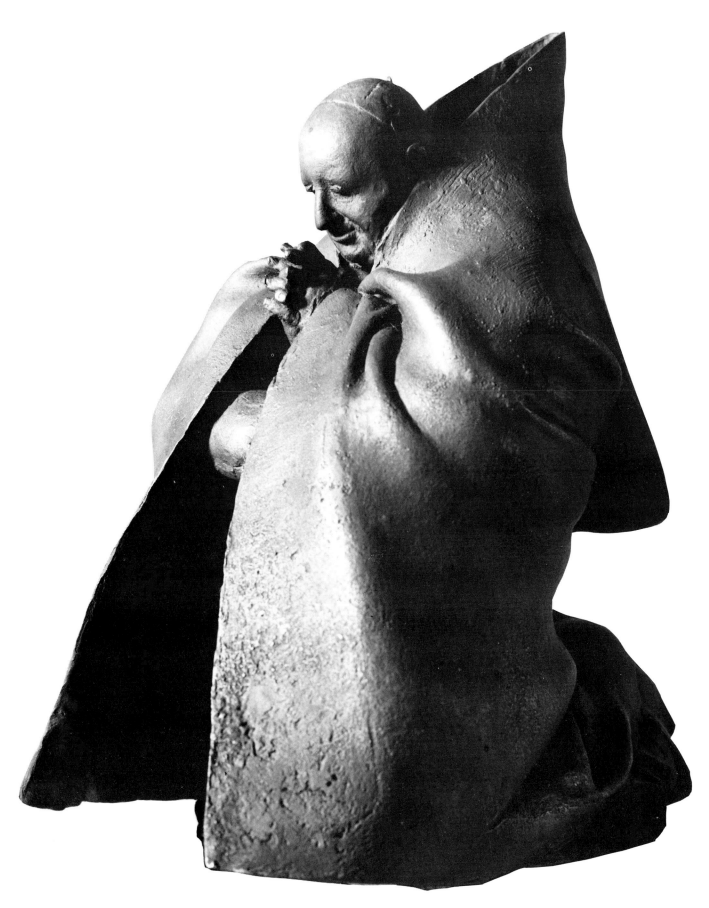

Pope John. Bronze, cast from terracotta, 11″ (27.9 cm) high, 1975. Photo: Bolotsky

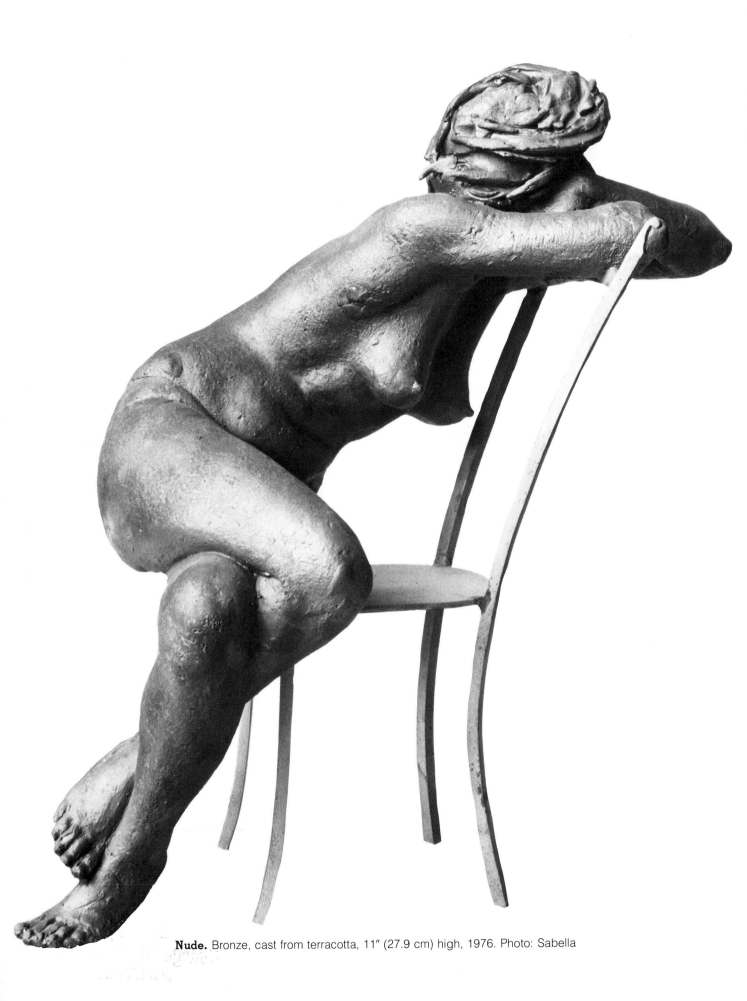

Nude. Bronze, cast from terracotta, 11″ (27.9 cm) high, 1976. Photo: Sabella

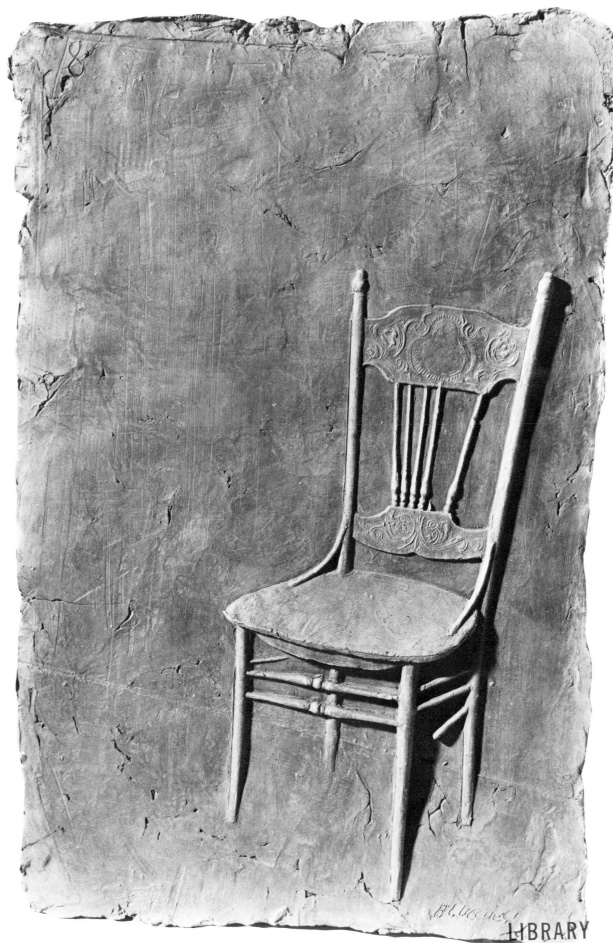

Chair. Terracotta relief, 12″ x 18″ (30.5 x 45.7 cm), 1972. Private collection. Photo, Cologne

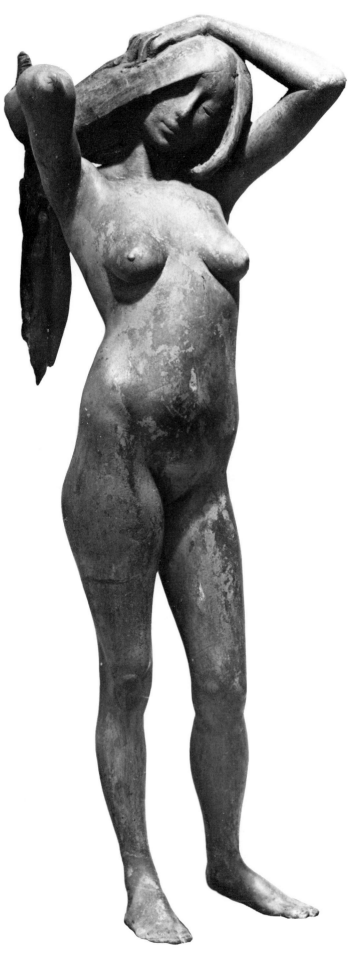

Brushing Hair. Terracotta, 18″ (45.7 cm) high, 1974. Private collection. Photo: Walter Russell

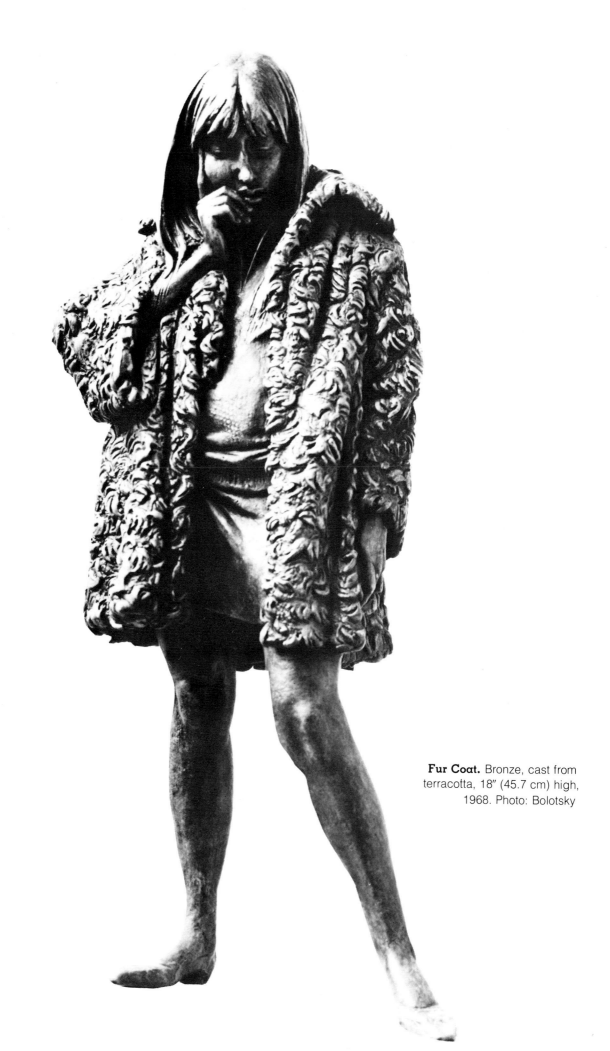

Fur Coat. Bronze, cast from
terracotta, 18″ (45.7 cm) high,
1968. Photo: Bolotsky

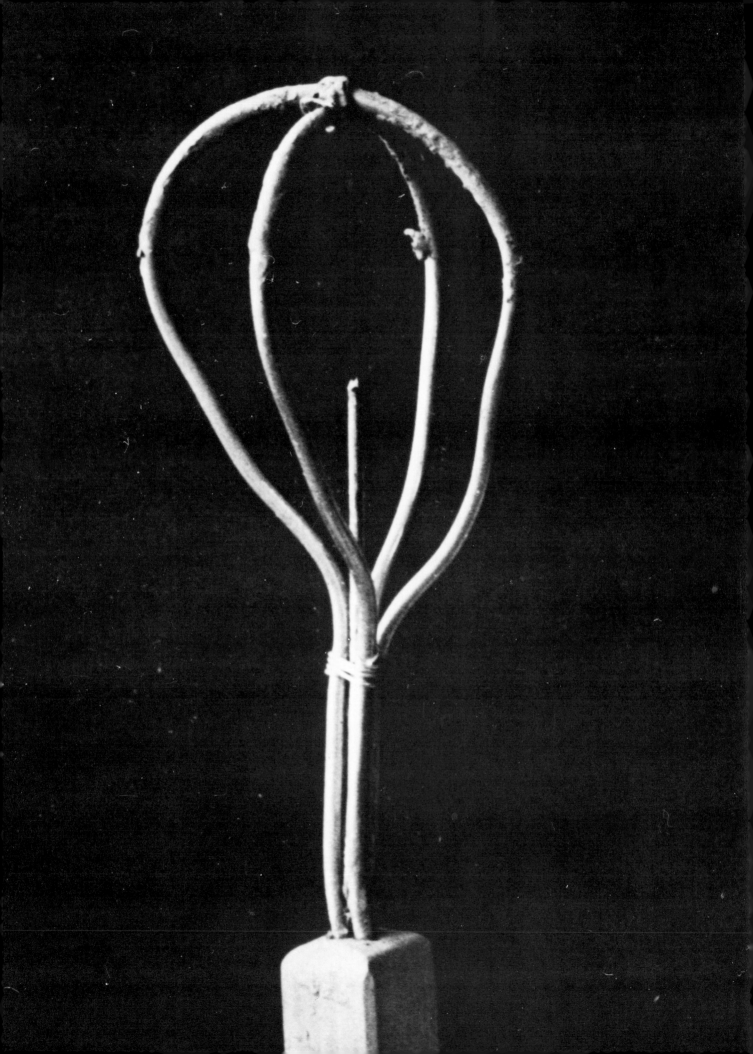

TOOLS AND MATERIALS

In this chapter we'll discuss only the tools and materials needed for terracotta sculpture, not for sculpture in general. Also, we'll describe the particular tools used by Bruno Lucchesi.

CLAY

Terracotta sculpture is made from low-fire water clay. It comes in a variety of colors, from gray to buff to different shades of red, but the most common color in terracotta work is red, the color of which is also referred to as "terracotta." Red clays may be purchased under many different names, depending on the manufacturer, but the word "red" will usually appear in the name—Colorado Red, Malone Red, Princeton Red, for example. When purchasing clay, make sure you specify clay which contains no grog (finely ground fired clay which is added to the clay body to make it rougher, used by potters). When you first open the plastic wrapping that the new clay comes in you may notice an unpleasant chemical odor. This will disappear as you work the clay. The clay may be stored in the container it comes in indefinitely. Of course, after you open the plastic wrapping the clay will eventually dry out if not kept covered between sessions. If you find that the clay is becoming hard, simply lay a wet towel on top of it and close up the plastic. Even clay that has dried completely can be reconstituted by adding water. The clay can be used just as it comes from the package: no wedging is necessary as it is in pottery. Clay may be purchased in 5-lb. (2.25 kg) packages from art stores carrying sculpture supplies. For larger amounts you'll have to go to the sculpture supply outlets, who sell clay in 50-lb. (22.5 kg) packages or cans.

ARMATURES

Although it's possible to fire a piece with armature wire inside it, Lucchesi never does. Also, the armature could not be the conventional figure armature sold in art supply stores because this is attached to lengths of pipe which are in turn attached to a Formica-topped base. And you could not put all that in a kiln. You would have to construct your own wire figure so that, with the completed clay sculpture, it could be removed from whatever supported it and fired.

Lucchesi's technique is especially designed to get around the armature problem: he never uses armatures in the conventional sense. He uses supports and he uses armatures as supports, but the sculpture is always removed from its support before firing. Each piece dictates the kind of support it needs. Lucchesi uses two kinds of armatures for the demonstrations in this book: a two-pronged armature and a head armature. We'll also discuss a single-rod armature because it's easy to make and offers adequate support.

Two-Pronged Armature. This is the armature Lucchesi uses most often. It's made especially for him out of iron rod by a metalworking company, but anyone with a welding torch could make a similar one. The basic idea is that the figure is freestanding, held up only by two prongs that pierce the back or buttock area. The prongs must be clear to the end—that is, they must not have any outcropping at the ends which will make them difficult to slide out of the piece once it's finished. And there must be two prongs; one won't do. The double prongs keep the piece balanced in a straight upright position. With one prong alone, the piece tends to tip to one side or the other, especially when the clay starts to dry and shrink up off the base of the armature. Another feature is that the prongs can be moved up and down the supporting rod to adjust to the height of the sculpture. Their position is secured at the desired height by a wing nut. The best way to understand how this armature is made is to study the illustration.

Head Armature. For portraits Lucchesi uses the lifesize, 18" (45.7 cm), head armature commonly available in art supply stores that carry sculpture materials. Instead of filling the wire "egg" with clay as you would if you were going to cast the piece, he builds the clay head around a core of newspaper stuffed into the wire. When the head is completed, he slices it in half, removes it from

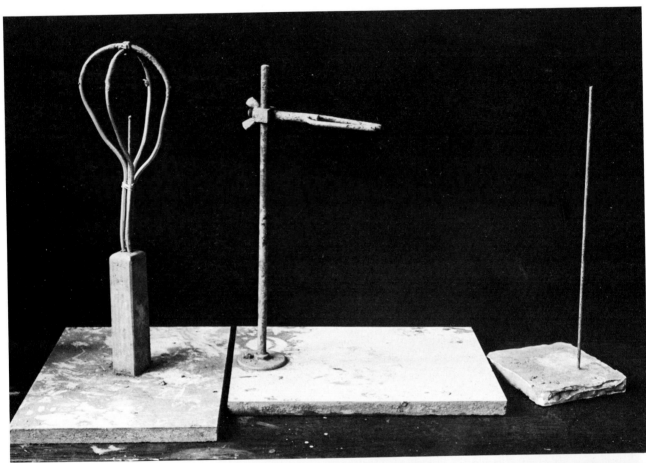

These are the three arma-
tures typically used by
Lucchesi: a lifesize, 18"
(45.7 cm), head armature;
the two-pronged armature
made especially for him
(see detail); and a simple
rod secured in a plaster
base. The base for this
last armature could also
be wood or Formica-
topped composition
board, as described in the
text.

Detail of Lucchesi's two-
pronged armature. If you
want to have this armature
duplicated, it might help
if you show the welder
who does it for you this
illustration.

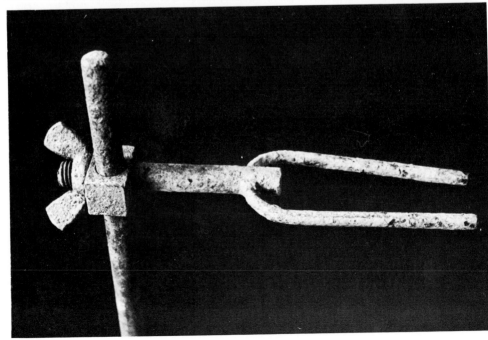

the paper core, hollows the halves out still more, then "glues" them together again with slip (which we'll discuss later in this chapter). This process is shown in Demonstration 5: *Portrait Head.*

Single-Rod Armature. This is an easy armature to make. Simply drill a hole in a 1″ (2.5 cm) thick piece of wood or Formica-topped composition board. This base could be the same size as a conventional armature base, 15″ x 13″ (38 x 33 cm), or you could make it any size you wish. Position the hole off-center, not in the middle. Then secure an iron rod, available from some hardware stores and from ironmongers, about 2/16″ (3.2 mm) in the hole with a generous dab of epoxy glue (which we'll also discuss later on in this chapter). The rod should not be more than about a foot (30.5 cm) high. To build a figure on this kind of armature, simply wrap clay around the rod to form the supporting leg. The rest of the figure is built out from the supporting leg, and the rod also goes up into the body. It's all right if the top of the rod pierces the head or comes up through the shoulder. When the piece is finished, slide it gently up the rod until it comes off. The clay should be firm enough at this stage so that the figure will stand by itself with no problem. The hole left in the head or shoulder can then be plugged in with clay and the surface smoothed over. The rod will leave a hole running the length of the piece, so remember to leave an opening somewhere for the gases that will build up in the cavity during firing to escape. We'll be talking more about this as we go along.

MODELING STAND
You'll need a full-size modeling stand on which to work. These come in a wide variety of styles and cover a broad price range, from about $30 to well over $100 (£15 to over £50). Because terracottas cannot exceed a certain size or they won't fit into the kiln, you won't need a heavy-duty stand. Here's a case where the moderately priced item is exactly what you need. All stands can be adjusted up and down to the desired working height, all have rotating modeling surfaces, and some are equipped with casters for mobility. The best way to find a stand that you'll be comfortable working on is to go to an art store or sculpture supply house and look over the selection. If you don't like the selection you see try somewhere else. Another way to see what the possibilities are is to get catalogs from several sculpture supply outlets (see *Suppliers* at the back of the book) and look at the photographs of the modeling stands they offer.

WORKTABLE
A worktable is simply any fairly large table that you reserve for your sculpture work. You'll be hollowing out, repairing, finishing, doing odds and ends of carpentry, and gluing. And for this you need a worktable, not a dining room table. Another kind of worktable that can come in handy is a smaller one, perhaps a rolling office typewriter stand, on which you can put your water container, clay, mister (spraying device to keep the clay moist), and tools while you're working. There's no room for these things on the modeling stand. Lucchesi partially solves the problem of where to put things so that they're within easy reach and yet out of the way by nailing a tin can to one side of his stand to hold his modeling tools.

MODELING TOOLS
Anything in the hand of a sculptor is a modeling tool. Lucchesi seems to pick up any object that comes to hand to use in modeling—a pickax head, an old scrub brush, a length of pipe, a piece of wood, a broom handle, a piece of rag; in short, the entire movable contents of his studio. So keep an open mind about what constitutes a modeling tool. But as a basic guide, here are the items Lucchesi uses consistently for modeling clay.

Wooden Modeling Tools. These are the mainstay of the sculptor, the extensions of his hands. They come in all sizes and shapes and are

made out of boxwood, maple, and rosewood, as well as plastic. They are always differently shaped at each end, so you get two tools in one. The only way to choose the tools that you're going to feel comfortable working with is to buy an assortment: pointed ends, serrated ends, squared-off ends, rounded ends. You'll find that as you work you'll keep reaching for the same one or two tools; then you'll know which shapes are right for you. Modeling tools are available wherever sculpture supplies are sold.

Wire-end Tools. These are modeling tools with wire loops at one or both ends. The other end of a single-end wire loop tool is the same as a wooden modeling tool. The loops are made of steel or brass and the wire can be round or flat. Wire-end tools, like wooden modeling tools, are available in a wide assortment of shapes—oval, squared-off, diagonally pointed—with a differently shaped tool at each end. They also come in a variety of sizes and weights. Some are made of very fine wire in an aluminum shank; these are excellent for detail work, especially around the face. Others are made of thick wire wrapped around with thinner wire for added strength; these are good for pulling away large slabs of clay and for hollowing out. Again, buy a good assortment of shapes, sizes, and weights. These are also available wherever sculpture supplies are sold.

Steel Plaster Tools. These are also known as Italian plaster tools because they are commonly made in Italy. Plaster tools are intended for working plaster casts, but they're very useful for modeling clay as well. Plaster tools, like modeling tools, come in a vast assortment of styles and sizes and have differently shaped ends to give you two tools on one shank. You'll find the most useful shapes are a fine-pointed end, a squared-off end, and a large knifelike slicer. These are available from sculpture supply outlets.

Palettes and Block Scrapers. Palettes come in wood, rubber, and flexible steel. They may be oval, oval with one straight side, rectangular, or partly serrated. These are actually ceramics tools, but Lucchesi uses them, especially the flexible steel palette in the oval and rectangular shapes, to blend and smooth the clay, round out forms, and scrape and slice away clay. The larger, more rigid version of the rectangular steel palette is called a block scraper. These tools are available wherever ceramics and pottery supplies are sold, where they are all called scrapers, and from sculpture supply outlets.

Burlap and Fabric. Lucchesi cuts burlap into small squares to use both wet and dry as a blending, texturing, and modeling tool. He uses bits of fabric, some heavily textured in the weave and some smooth, in the same way. The results, of course, are different, as the burlap leaves a coarse imprint on the clay surface and the fabric leaves a finer one. Burlap (hessian, in the United Kingdom) is available from sculpture supply outlets, because it's often used in making plaster casts. You may also be able to get it in the form of burlap bags from a coffee importer or your local greengrocer. Some hardware stores also carry burlap bags.

Wire Screen. Lucchesi keeps bits of wire screening of different meshes around the studio for modeling and texturing. Screen is available from hardware stores, but not all stores will sell it in small amounts.

Brushes. Brushes of all kinds, sizes and shapes are essential, from delicate, fine-tipped watercolor sables to large housepainter's brushes. Lucchesi even has a couple of scrub brushes around the studio which he puts to excellent use, as you'll see in the demonstrations. Brushes are used either wet or dry for smoothing and blending the clay. And for detail work—around the eyes, nostrils, and lips, for example— nothing can beat a pointed sable dipped in water. Brushes are available from art supply stores, hardware stores, five-and-ten-cent stores, and even stores selling kitchen utensils, as the brushes used for glazing foods are also fine for modeling.

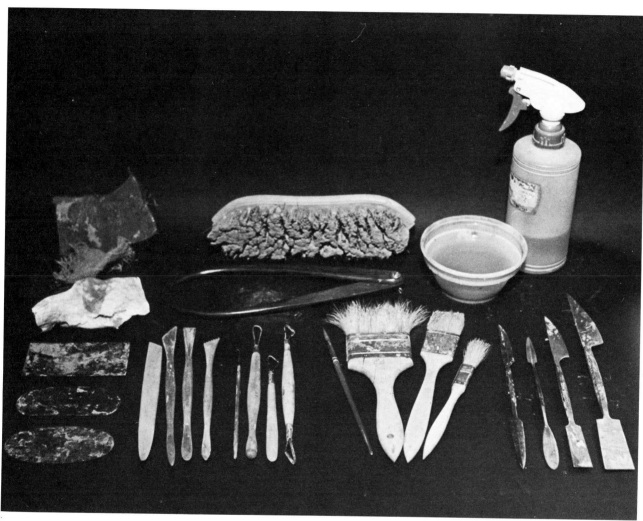

This assortment of sculpture tools shows a good variety of the kinds of tools you'll be using. Left, top to bottom: pieces of wire screen, burlap, and fabric; three flexible steel palettes. Top: a scrub brush and a pair of calipers; plastic water dish and plant mister. Left to right: four wooden modeling tools, four wire-end tools, a fine-tipped sable watercolor brush and three bristle brushes; four plaster tools.

GLUES

There are two kinds of glue you'll be using in terracotta work: slip to glue the wet clay and epoxy to glue the fired clay.

Slip. Slip is simply clay that is mixed with water to give it the consistency of heavy cream or yogurt. If a piece breaks off your sculpture while you're modeling, a finger for instance, it can be "glued" right back on with slip. Slip is also used to "glue" together a sculpture that has been removed from its armature in pieces. As long as the clay being glued is moist, the slip will form a firm bond in seconds. If the clay is too dry, however, it will suck up the water in the slip, rendering it ineffective. Keep a container of slip handy while you work.

Epoxy. Epoxy is a glue made up of two elements, a plastic compound and a catalyst. When mixed in equal proportions, the catalyst acts on the plastic to harden the compound to an almost indestructible bond. There are 5-minute epoxies and 24-hour epoxies. The 5-minute epoxy hardens in 5 minutes, so you have to work fast. It's strong enough for most purposes. If, however, you're suspending a lot of weight from the bond, you might want to be on the safe side and use a 24-hour epoxy, which is stronger. When working with epoxy keep a container of water and some tissue or paper towels on hand. If you get epoxy on your hands, wipe it off immediately with a wet tissue. A little epoxy on your hands won't harm you but it's hard to work quickly and cleanly—as you must—when your hands are sticky. Also, it's impossible to remove the stuff once it's hardened; it has to peel or wear off by itself. Epoxy comes either in two separate tubes or in a single container divided into two tubes. On a clean, flat surface, such as a small piece of plywood or heavy paper, squeeze out equal amounts of the two elements and mix thoroughly. For 5-minute epoxy mix only as much as you can use in 5 minutes; otherwise it will harden before you have a chance to use it and be wasted. Anything you mix and apply the epoxy with will become coated with the glue, so don't use anything that you're not prepared to throw away. If you spill epoxy, don't try to wipe it up while it's still wet; wait until it's tacky and you'll be able to pry it right off with any sharp-edged implement. Epoxy is available in hardware stores.

STUDIO ODDS AND ENDS

Here are some of the things that you'll need in your work area or studio.

Calipers. These come in aluminum or wood and are used for measuring proportions. They are most useful when working from a live model or doing a portrait head to check your work against the sitter. Calipers are available in a range of lengths from sculpture supply outlets and pottery suppliers.

C-Clamps. Armatures are always affixed to their own base. It's wise to secure this base to your modeling stand with a C-clamp so that you don't inadvertantly knock the armature, with your sculpture on it, off the stand. C-clamps (G-cramps in the United Kingdom) are available in a range of sizes from hardware stores.

Containers. Collect them in all sizes and shapes. You'll need a small container for water, a larger container for slip, and a still larger container to store your dried-out clay for reconstitution. You'll need a place to keep your modeling tools, your brushes, and your odds and ends of fabric, burlap, screen, etc. The containers that will hold water and slip should of course be plastic or some other rustproof material. You can use plastic mixing bowls and refrigerator storage containers from the five-and-ten, jam jars, pottery mugs—in short, whatever suits the purpose.

Wire. Wire of various thicknesses has a number of uses around the studio. Lucchesi uses a moderately thin wire to pierce vent holes in pieces before firing (we'll talk about this in the demonstrations) and heavier wire for constructing props, such as the chair for the seated figure in Demonstration 2. Wire is available from hardware stores.

Wire Snips and Scissors. Wire snips are of course for cutting wire; scissors, which should be heavy-duty, are for cutting burlap, screen, and fabric. Both are available from hardware stores and five-and-tens.

Rags. Every sculptor's studio should have a rag bin full of old towels, undershirts, etc. These are used wet as wrapping cloths to keep the clay moist as well as for smoothing and texturing the clay while modeling.

Plastic Wrapping. Plastic wrapping in the form of dry-cleaning bags, garbage bags, food-storage bags, drop cloths, and even shower-curtain liners has a multitude of uses. Plastic is wrapped around the wet cloth to keep the moisture in a sculpture between working sessions; it is placed between the clay and the working surface to keep the sculpture from sticking; and it can be used as a drop cloth to keep things clean.

Sand. Lucchesi sprinkles a little sand on his working surface to keep the clay from sticking. A plastic sheet may also be used for this purpose, or even a piece of tin foil. Sand is available wherever terrarium or aquarium supplies are sold.

Plant Mister. A spray with the common plastic mister sold in plant stores, hardware stores, and five-and-tens is the best way to keep clay moist while working.

FIRING EQUIPMENT

If you intend to send your sculpture out to be fired, skip this section. However, if you're going to purchase a kiln and fire your work yourself, this is for you.

Kilns. A kiln will be your major investment in terracotta work. Kilns run from a couple of hundred dollars (a hundred or so British pounds) on up, depending on the manufacturer, the size, and the weight. The larger and heavier the kiln, the more it will cost. Any kiln that fires pottery is suitable for firing terracotta sculpture. A ter-

racotta firing is simply a low-temperature firing, or what potters refer to as a bisque firing. For sculpture, however, the temperature should be brought up very slowly (see the firing schedule in the chapter *Firing and Finishing*). Kilns are fueled by oil, wood, gas, or electricity, but if you're going to buy your first kiln specifically for terracotta sculpture a top-loading electric kiln is recommended. The kiln Lucchesi has owned for the past ten years is a Skutt model 181. It's an octagonal top-loading electric kiln with a maximum firing temperature of 2250° F. (1331° C.), about cone 6, which is stoneware temperature. Lucchesi fires his sculpture in the bisque firing range of about 1830°–2048° F. (1000°–1120° C.), cone 06–02. Lucchesi's kiln is lightweight at 130 lb. (58.5 kg), and portable in that it is assembled in sections and can be easily dismantled. It's the kind of kiln that can be purchased and brought right home in car or cab. The inside dimensions are 18″ x 18″ (45.7 x 45.7 cm), but pieces taller than 18″ can be fired by propping them up diagonally.

The largest kiln that can be plugged into a regular home wall outlet (110–150–120v) is 15″ (38 cm) interior height. Anything larger than that requires 220 current and comes with a special plug for which an outlet must be properly installed by an electrician. Before shopping for a kiln, find out what the electrical capacity of your wiring is. This information can normally be found on the inside of your fuse box door or on the heads of your fuses or circuit breakers. But if you have any doubt about your wiring call in an electrician. For your kiln to work properly and to make sure your fuses don't blow, the volts and amps on your fuses should be the same as, or more than, those printed on the nameplate of the kiln. It's a good idea when shopping for a kiln to have this information handy so that the salesperson can make sure you get a kiln suited to your electrical capacity.

Kilns are insulated against heat loss, some more than others. But even with insulation they must be placed well away from walls and combustibles. Heat from the kiln will also be transmit-

ted to the floor underneath it, even when the kiln has a stand. Wood floors and vinyl and asphalt tiles can be damaged by the heat. To protect your floor, you can raise the kiln up, stand and all, on a layer of brick or ceramic tiles. Or you can lay a sheet of asbestos on the floor. The soft asbestos sheet, Homosite, shreds, and so on should be sandwiched between two sheets of aluminum and bound up with tape along the edges. If you use the hard asbestos sheet, Transite, you can make a second stand under which air can freely circulate by placing the Transite on four ½″ (1.3 cm) kiln posts or bricks and then positioning the kiln and kiln stand on top of this.

When it's time to buy your kiln, remember that you don't need a 400-lb. (180 kg) kiln suitable for production pottery or institutional use. You need one that's large enough to accommodate the kind of work you do and lightweight enough to handle. The more insulation a kiln has, the heavier it is. Lucchesi's Skutt 181, for example, has only one layer of insulating firebrick encased in a stainless steel jacket, and at its firing peak it becomes too hot to touch. But so does an oven. You'll have to decide for yourself what characteristics are most important to you and take into consideration what your premises can accommodate in terms of weight and electricity.

Your kiln should have a complete temperature range so that you will have the option of experimenting with the variety of colors and characteristics possible when different clays are fired to different temperatures.

Kilns may be purchased with a pyrometer or an automatic shutoff and/or timer. A pyrometer shows the temperature, like an oven thermometer. When the temperature you want is reached, you shut off the kiln. An automatic shutoff is a device that is triggered by a Junior cone (see next section) to shut the kiln off automatically when temperature is reached. A timer can be attached to the automatic shutoff to shut the kiln off after a given amount of time has elapsed. This is a good backup to the automatic shutoff, especially if no one will be around when the kiln

should be shutting off. The automatic shutoff system works on a very simple trigger system based on a cone sagging and thus releasing a weight which falls and shuts off the kiln. Any object that blocks either the sagging of the cone or the falling of the weight will impede the functioning of the device. A timer ensures that even if the automatic shutoff doesn't function, your kiln will shut off after a given number of hours.

Kilns are available from some sculpture supply outlets and pottery suppliers, and they all come with complete instructions for installation and use. (See *Suppliers* at the back of this book for a listing of both kiln manufacturers and dealers.)

Cones. Orton Standard pyrometric cones are elongated pyramid shapes made from pressed clay. They come in two sizes: Junior, 1⅛″ (2.9 cm) long, and Senior, 2½″ (6.4 cm) long. Cones are marked with a specific cone number which corresponds to the temperature at which they will bend completely over. Cones range from cone 022, the lowest, which bends at 1112° F. (600° C.) to cone 15, which bends at 2608° F. (1431°C.). When the cone bends, you know temperature is reached and it's time to shut off the kiln.

Both Junior and Senior cones can be used as visual checks. They are placed inside the kiln in view of one or more of the peepholes. Junior cones are used in the automatic shutoff system. To set the automatic shutoff you simply put the cone in place and set the device. When temperature is reached the Junior cone will sag, tripping the device and shutting off the kiln. (Complete instructions for setting the automatic shutoff will come with your kiln.) Orton cones are available wherever ceramic supplies are sold.

Kiln Furniture. To load your kiln most efficiently you may want to get an assortment of kiln furniture: shelves and posts. Shelves are available in full and half shelves. When buying them make sure you know the inside dimensions of your kiln so you'll get the right size. Posts are used to prop up the shelves and come in a range of

lengths from ½″ (1.3 cm) high to 12″ (30.5 cm) high. The short ones can also be used to prop ware up off the kiln floor for better heat circulation. Posts are also available in sets consisting of short sections that fit into each other piggyback style to make any height desired. Kiln furniture is available wherever kilns are sold.

FINISHING AND MOUNTING TOOLS

There are many ways you can finish, or patine, terracotta sculpture. You could paint it or glaze it. But one of the beauties of the material is the natural color and texture of the bisque-fired clay. Lucchesi has devised his own patina to take advantage of the clay's characteristics. He also most often mounts his work himself. Here are the materials he has in the studio for finishing his pieces.

Liquid Wax. This is the ordinary household floor wax sold in supermarkets. Lucchesi uses Glo-Coat but any liquid wax would do. The liquid wax forms the basis of his patina solution. It seals the pores of the clay and imparts a sheen to the surface. It can be removed with wood alcohol.

Colors. Lucchesi uses water-soluble or alcohol-solvent aniline dyes mixed into the liquid wax to patine his fired sculpture. These are available from art supply stores and hardware stores.

Shoe Polish. Lucchesi mixes brown cake shoe polish into the liquid wax to darken the patina. He also rubs the polish into the waxed piece to highlight certain areas.

Water Putty. This is used in filling cracks in the fired piece and for building up sections if necessary and is available from hardware stores in powder form.

Sandpaper. This is used for smoothing the water putty after it has hardened. It can also be used to smooth fired sculpture.

Electric Drill. An electric drill is essential for any repairing or mounting requiring the insertion of a pin, a rigid iron or copper rod, into the sculpture. You should have a full assortment of high-speed wood bits (they come in a set) and the smallest available, ⅛″ (3.2 mm), masonry bit. The wood bits are for drilling into bases for mounting; the masonry bit is carbide-tipped and is for drilling into the fired sculpture. If the masonry bit is too narrow, there's a full range of larger sizes.

Iron or Copper Rod. This is used for pins in repairing and mounting and is available at some hardware stores and from ironmongers.

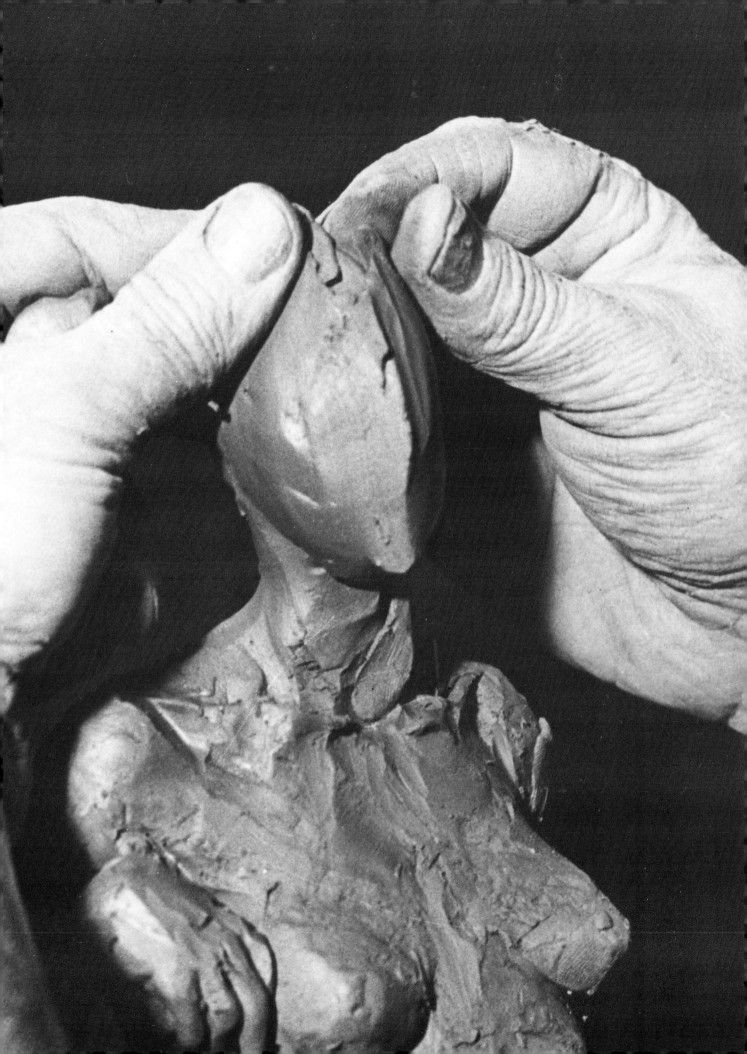

WORKING WITH TERRACOTTA

Terracotta offers possibilities to the sculptor not found in any other medium. In this chapter we'll see how these possibilities can best be coaxed from the clay; in other words, how to work with the material to take advantage of its unique characteristics.

Terracotta is water clay, that is, it's water-soluble material. Its consistency when you unwrap a package of new clay is perfect for modeling. If you add water the clay becomes softer; if you allow it to dry out it becomes harder. The texture of the new clay is a bit like chocolate mousse, with tiny pinpricks of air throughout the clay body. These are not what we mean when throughout the book we refer to air pockets or bubbles, however. They are part of the clay's natural composition and will disappear as you work the clay.

ELIMINATING AIR POCKETS
These are actual spaces that form when the clay is not thoroughly worked together. During the firing, the gases that build up in these spaces, unless they have an escape route out of the piece, will cause the sculpture to explode. Lucchesi lessens the possibility of air pockets being trapped by slapping the clay on hard, while he's building up his pieces, and by working each bit of new clay into the clay mass firmly. Although this is a major consideration to keep in mind while you're working, especially when you're roughing out the basic form, don't be timid about adding clay because of it. As you work there will be a natural amount of pushing, pressing, and flattening which will help obliterate air pockets. And if your piece should explode in the kiln, you can always gather up the fragments and glue them back together again with epoxy (see "Repairing a Break" in the chapter *Firing and Finishing*).

Another way to cut down on air pockets is to keep the clay wall as thin as possible. In the broad parts of the figure, such as in the torso or in the base, this is accomplished by building the clay around a core, which will either be removed before firing or burn out during firing to leave the

space hollow. Unless this hollow space is open at the bottom, as in a head which is hollow right down through the neck, it becomes the biggest air pocket of all. To let the gases escape, vent holes are pierced through the clay wall into the hollow area. We'll be talking more about this throughout the book.

BUILDING A FIRM FOUNDATION
The idea of this book is to show you how to build your terracotta sculpture without the traditional wire armature inside to support the clay. Therefore, one of the first things to master is how to construct your piece so that it will be strong enough to support its own weight. Wet clay is very heavy; the wetter it is, the heavier it is. Wet clay also sags and falls out of shape in direct proportion to its wetness. This means that the earlier stages of roughing out the piece should be done with fairly firm clay, as it comes from the container or even less wet than that. Don't wet the clay or smooth it too much at first. Prop up any portion that seems to be sagging. After you've established a firm foundation, then you can work the surface in any way you want, even very wet, without undermining the essential form.

KEEPING THE CLAY MOIST
As you work, the clay will dry. One of your jobs will be to keep the clay moist enough to handle. To wet the clay while you're working, spray it with a plant mister as necessary. To keep it moist between sessions, wrap the piece in a damp cloth covered with a plastic sheet. Close the plastic tightly around the bottom with a string or a refrigerator-bag tie. In the case of a flat piece, tuck the plastic in all around or weight it down. If you want the clay to dry out a bit, dispense with the damp cloth and wrap the piece in plastic only. And if you want the clay to dry out still more, leave the plastic slightly open.

USING WATER AS A TOOL
Because terracotta is water clay, water is an actual tool used to work it. You can dip your fingers in water and smooth them over the clay surface;

you can swirl a wet paintbrush over the clay to blend and texture it; you can press and mold the surface with a damp cloth or piece of burlap. In other words, water isn't just for keeping the clay wet. It's for working with, too. Water is what gives this medium a special quality you won't get with oil-based clays, making the modeling process a sensual, tactile experience rather than a mere building up of form. You can really touch the material, move it around, manipulate it any way you wish—even get into your work up to your elbows if you want.

KEEPING THE CLAY FROM STICKING TO THE SUPPORT

When the wet clay comes in contact with any dry, porous surface, moisture is sucked out of the clay and into the surface. So if you construct your own armature or support keep in mind that you should never place clay around a wooden upright; the wood will soak the water from the clay and expand, causing the clay to crack, especially as the clay begins to dry and contract. Wood may be used as a modeling base or as a prop underneath a seated figure, for example, because when the clay dries it will simply contract into itself and not be pulled apart by an expanding object inside it. But even when Lucchesi uses wood for a base, he's careful to sprinkle it lightly with sand first to keep the clay from sticking. A piece of plastic wrapping spread over the wooden base serves the same purpose. But never build directly on a rigid plastic sheet such as Plexiglas (Perspex in the United Kingdom). The clay will stick to that even worse than it sticks to the wood because the clay isn't able to dry out sufficiently on the bottom to let loose, even when the top of the piece seems quite dry.

Another important thing to remember when fashioning a support or building a piece on any of the armatures discussed in *Tools and Materials* is never to attach clay firmly in more than one area at a time; that is, attach it firmly at one point and less firmly at all other points. This allows the clay to pull up and away as it contracts, finally

being supported by the single firm attachment only. If a figure is attached, say, to a pronged armature at the middle back and also smeared into a porous base at the feet, the shrinking action as the clay starts to dry will literally tear the piece apart unless the feet can come loose from the base.

DRYING THE CLAY

If you expose clay to the air, it will dry. However, if you want to hurry the process, lay a slab of clay out on any porous surface. A piece of unfinished wood or a slab of plaster of paris both work, as they suck the moisture out of the clay. Lay the clay down lightly; don't press it into the surface, or you'll have a job scraping it off. If you're in the middle of working and find the clay sagging so much that you can't control it, a propane torch (available in any hardware store) played over the surface of the clay will dry it out in minutes.

Stages of Drying. To make the clay that comes from the container softer you can add water— you can even dissolve it completely into a liquid, that is, slip, if you wish. Or you can let the clay dry out until it becomes bone-dry. There are stages in the drying process at which certain tasks can be done better than at any other time, the most crucial of these being the leatherhard stage. Leatherhard is a potter's term that defines a particular tough, leathery quality. This is the stage when potters decorate their ware with sgraffito (incised decoration); the clay is firm enough so that it will hold the smallest detail without blurring or filling in. Leatherhard clay can be incised and drawn into, carved almost like a very soft wood, shaved with a sharp tool; details can be emphasized and modeling heightened by undercutting between forms. The leatherhard stage is the perfect time to sign your name in the piece with a sharp-pointed tool or to trim away excess clay from the sides or bottom of the base. Once the clay reaches the leatherhard stage it starts to dry in earnest, very rapidly becoming too hard to work without rewetting. Then

the first lighter-colored dry patches appear and it's just a matter of time until the clay becomes bone-dry.

If you build your piece solid, intending to hollow it out from below before firing, or if your piece must be removed from a support or armature, do it just before it becomes leatherhard; while it's still soft enough to scoop into with a wire loop tool and still has enough moisture so that any new clay or slip that you add won't be immediately sucked dry and fail to bond. On the other hand, the clay must be firm enough so that you can pick it up without destroying the form or leaving dents and fingerprints. It's a matter of timing, and you can arrive at just the stage you require, when you want to, by controlling how fast you allow the clay to dry and by rewetting with a damp cloth if it gets ahead of you.

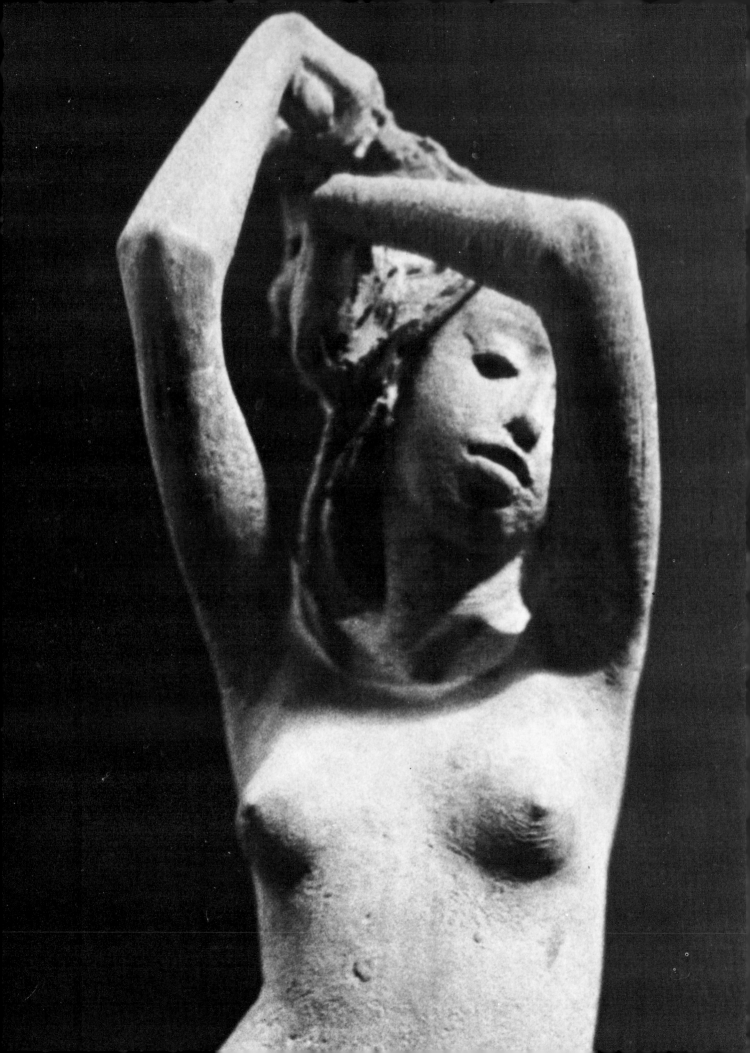

DEMONSTRATIONS

The seven demonstration sequences that follow show a variety of approaches. No single sequence covers the full range of possibilities. When looked at as a whole—and that's the way you should look at them—you'll find these demonstrations offer a full vocabulary of techniques. Become as familiar with as many of these techniques as you can so that you'll be able to use them interchangeably with imagination and freedom. In other words, no matter what particular type of figure you're interested in doing, study *all* the demonstrations. Try as many approaches as you can. Experiment. Above all, play!

You'll notice that as the first sequences near their conclusion there is a jump from rough modeling to finished piece. This is because the fine modeling techniques are more or less the same for all the pieces and to show them each time would be needlessly repetitive. Instead, we show these techniques in detail in a female torso and a male torso in Demonstrations 6 and 7. A similar approach was taken to show how to model the head and face. The details of modeling the features and hair are covered fully only in Demonstration 5: *Portrait Head.*

Except for the portrait head and the female torso, Lucchesi did not use a model for these demonstrations. His usual way of working is to begin a piece from an idea and to call in a model only if he feels it's necessary.

Lucchesi later fired all these demonstration pieces. Each was prepared for firing by being removed from the armature or support and being pierced with vent holes where necessary. Full details on how to prepare terracotta sculpture for firing and on the firing process can be found in the chapter *Firing and Finishing,* which follows the demonstrations.

DEMONSTRATION ONE
STANDING FIGURE

In this first demonstration Lucchesi makes a simple standing figure about 12″ (30.5 cm) high. The torso is hollow, so after the piece is finished but before it's allowed to dry out completely Lucchesi will pierce vent holes through the navel and nipples and up between the buttocks so that the gases that accumulate during firing will be able to escape. Without these holes the gases would build up and their pressure would break the sculpture.

The armature Lucchesi uses for this piece is one made especially for him. It is fully described under the heading "Armatures" in the chapter *Tools and Materials*.

This figure is built on its own clay base so that once it is removed from the prongs of the armature it will be able to stand. A figure doesn't necessarily have to have a base; it may be mounted on a regular sculpture base after it has been fired. But it's easier to work with a piece that's able to stand upright on its own.

1. Lucchesi firmly anchors a ball of clay on the prongs of the armature. This is the core of the figure: the other parts will be built out from this.

2. He flattens another ball of clay to form the base upon which the figure will stand.

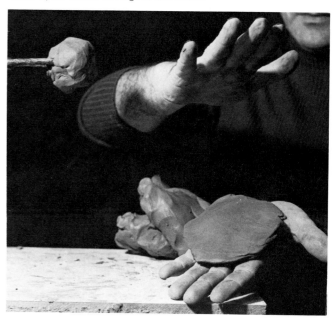

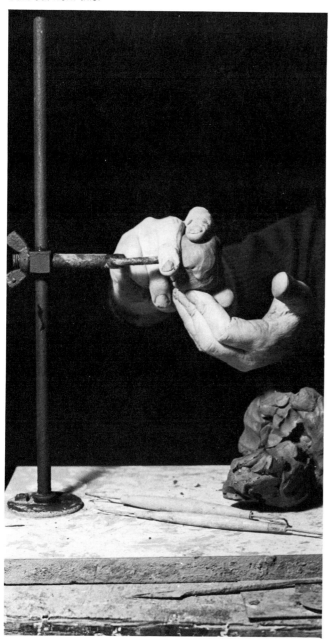

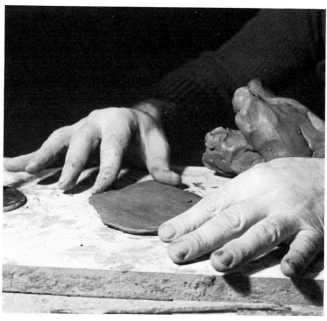

3. He has sprinkled the stand lightly with sand to keep the clay base from sticking to it, and now he places the base just below the core.

4. Lucchesi makes a leg by rolling a ball of clay between his palms until it forms a solid coil.

5. He attaches the leg at the hip (or core) on the armature, kneading the clay of the two parts together with his thumb.

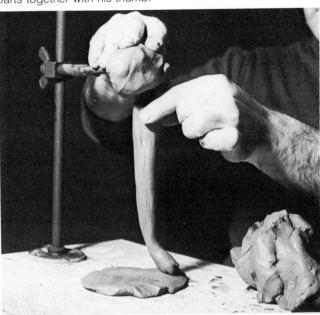

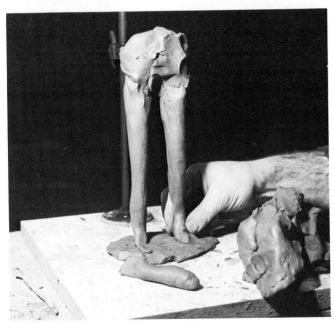

6. The second leg has been attached and Lucchesi presses the feet into the clay of the base.

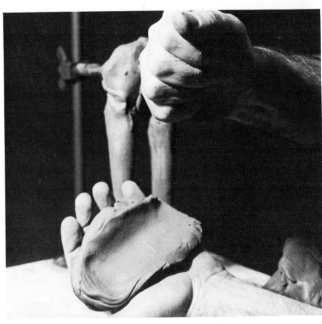

7. Lucchesi pounds another ball of clay into a rounded hollow shape for the back of the torso.

8. He attaches the hollowed back to the core, again by kneading the clay together with his thumbs. He supports the figure from behind with his fingers to equalize the pressure exerted by the pushing movements of his thumbs.

9. He places a bit of crumpled newspaper in the hollow of the torso. During the firing this paper will burn out, leaving the torso hollow.

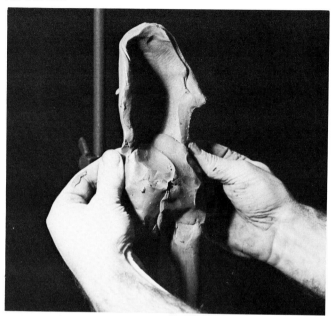

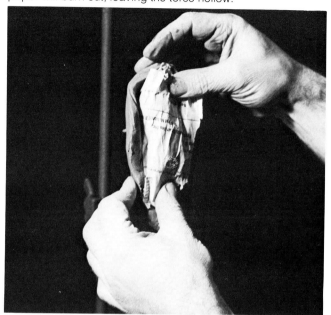

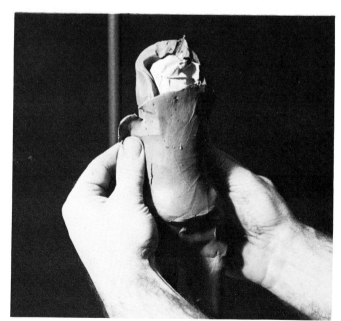

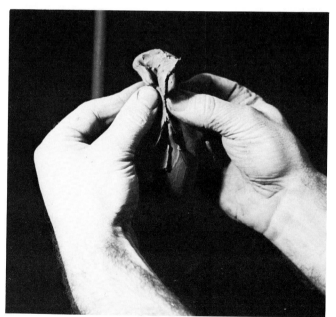

10. He pounds out another slab of clay, as in Step 7, and wraps it around the front of the torso, covering the newspaper. He works the clay into the core and the back.

11. He pinches the top of the torso in over the paper to form the neck and the beginning of the head.

12. He adds more clay to the head and pinches it down the middle to form the two sides of the face.

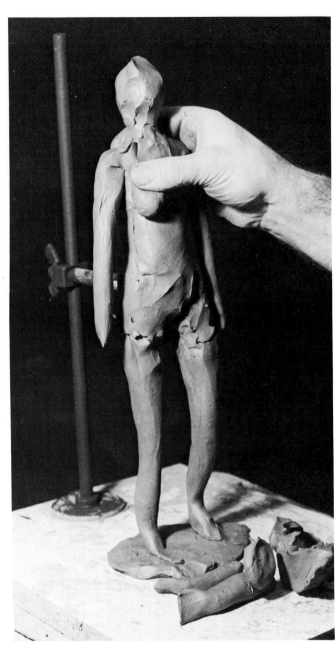

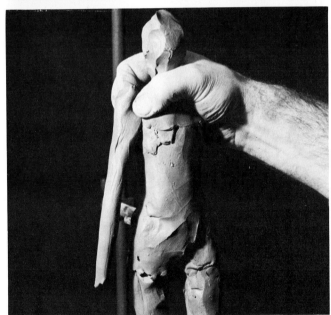

13. As he did for the legs, Lucchesi rolls out a coil of clay for the arms. He attaches the first arm at the shoulder, working it into the clay of the torso.

14. The second arm is on, and here Lucchesi adds a clay ball for the breast.

15. Lucchesi plays around with different poses, trying to find one he likes.

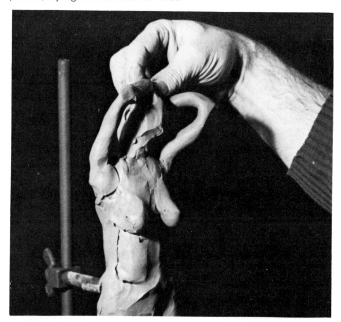

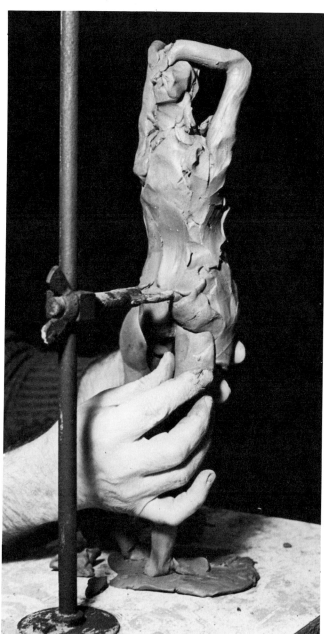

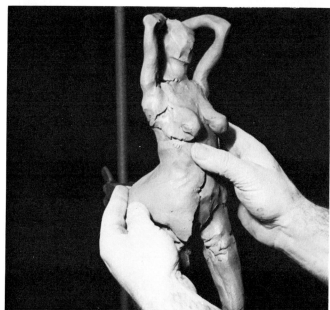

16. Now that the basic "stick figure" is sketched in, Lucchesi begins to flesh it out. Here he adds a slab of clay to the hip area.

17. More fleshing out, here in the thigh. Notice how much clay Lucchesi uses and how large an area he covers each time.

18. The figure is now built up enough so that Lucchesi can start to use tools. Here he defines the upper leg contour with a flexible steel palette, holding his other hand behind the leg to equalize the pressure.

19. He lays a flat piece of clay over the front of the head, like a mask. This will become the face.

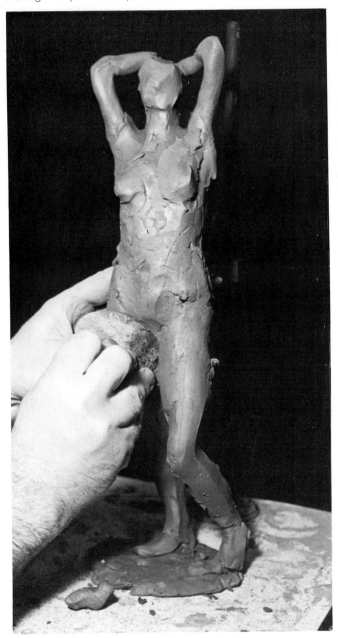

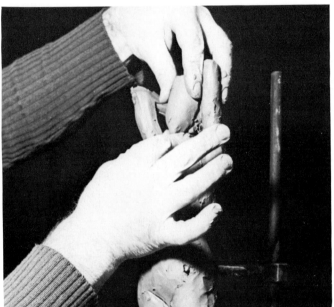

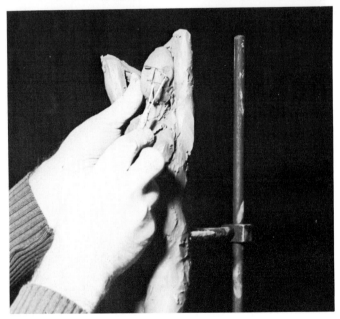

20. With a wire loop modeling tool, Lucchesi places the nose by gouging out the area around the eye sockets.

21. Another quick jab with the loop defines the lips.

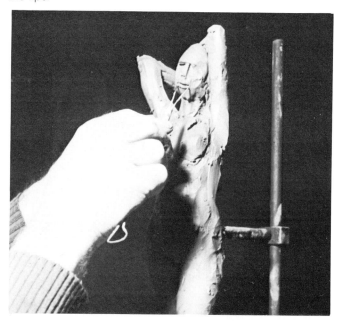

22. Lucchesi now turns his attention to further fleshing out:

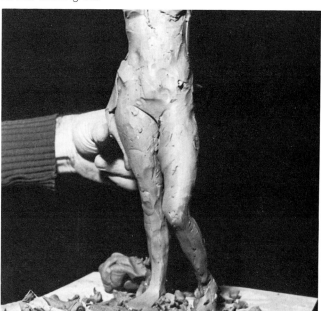

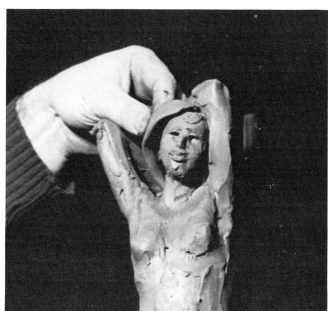

23. Lucchesi places a flattened, gently curved piece of clay on the head for the beginning of the hair mass. The face has been built up, with nose and lips added and eyes incised.

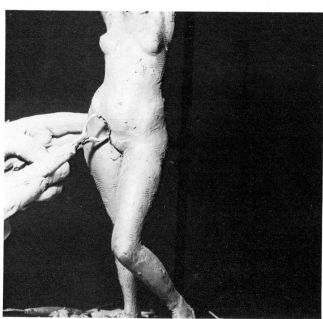

24. Considerable finishing has taken place over the surface of the piece. Here he carves out the forms with a wire loop tool. For a detailed description of these finishing techniques look at the female and male torsos in Demonstrations 6 and 7.

25. The piece is refined further. The finer the modeling, the greater the reliance on tools. Here Lucchesi emphasizes the anklebone of the supporting leg.

26. The finished figure, still attached to the armature.

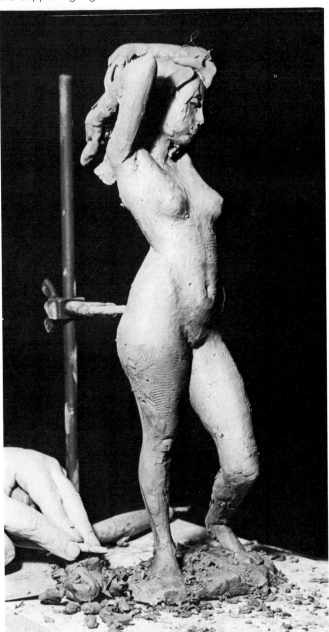

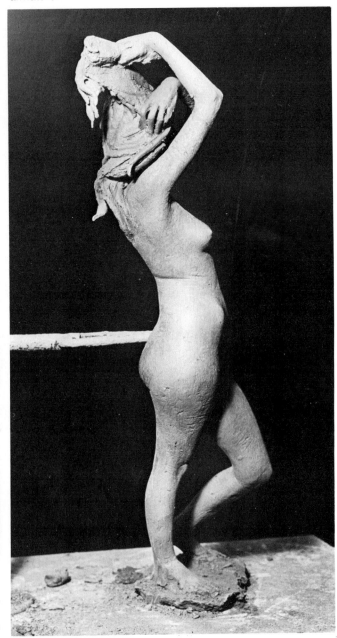

REMOVING THE ARMATURE

When the piece is finished, but before it is allowed to dry out, Lucchesi gently works it off the armature. If the piece should crack at the ankles at this point, it's best to lay it down to dry and leave the break alone. After the two parts are fired they can be glued together with epoxy. (See *Firing and Finishing* for more on repairing terracotta sculpture.)

He plugs the holes and smooths over the surface. If the piece is too dry it will suck the moisture from the new clay used to plug the holes, leaving two depressed craters instead of an even surface. To prevent this, thoroughly wet the holes with a paintbrush dipped in water before inserting the plugs.

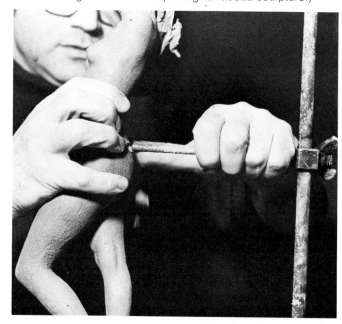
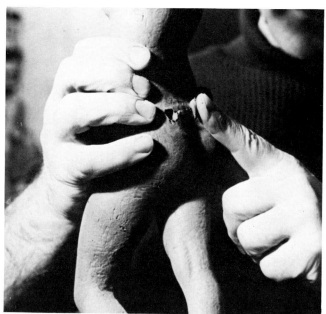

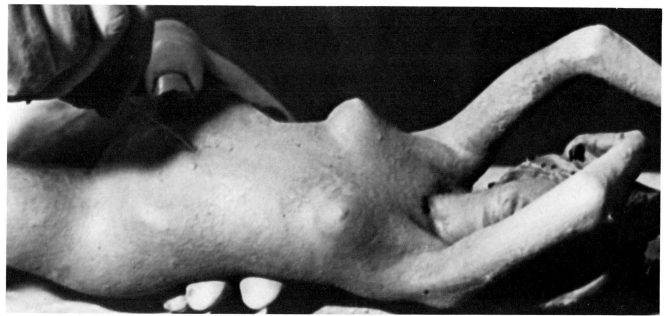

PIERCING VENT HOLES

Lucchesi pierces the figure, here through the navel, to let out the gases that will accumulate in the newspaper-filled core during firing. If this is neglected, the sculpture will break in the kiln. Piercing, too, must be done before the clay is allowed to dry out. Lucchesi pushes a length of wire through the clay wall until he feels the obstruction of the newspaper, then draws it out and camouflages the hole so that it's unobtrusive but still open. You needn't pierce a lot of vent holes. One or two will do as long as they offer a clear escape route for the gases.

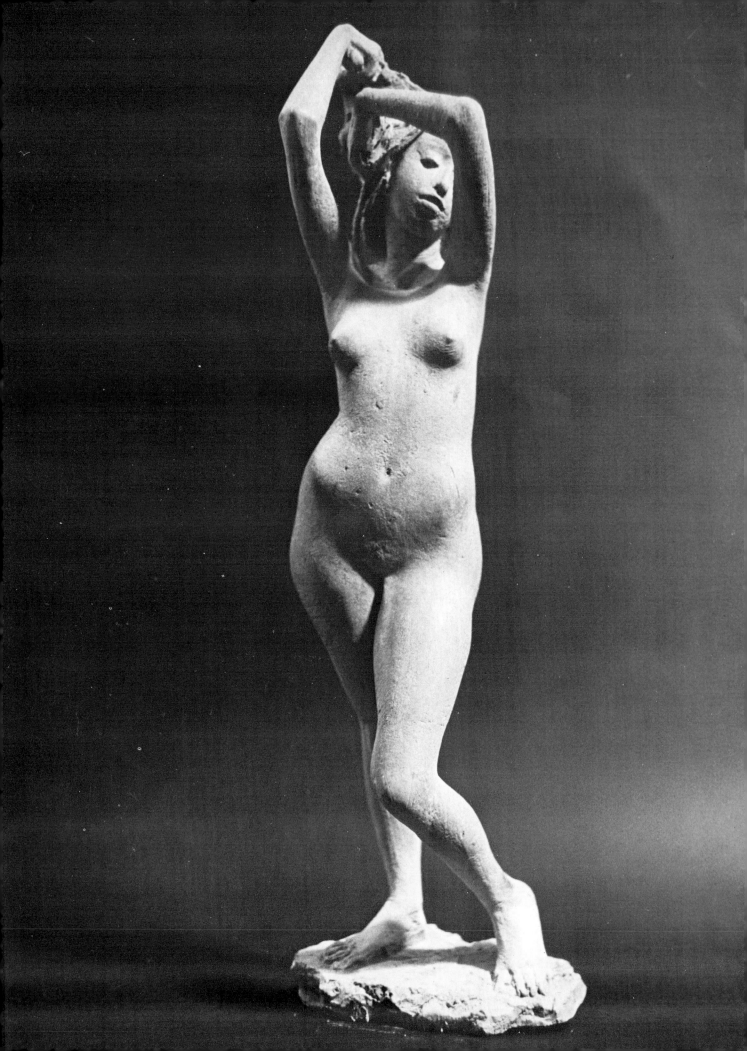

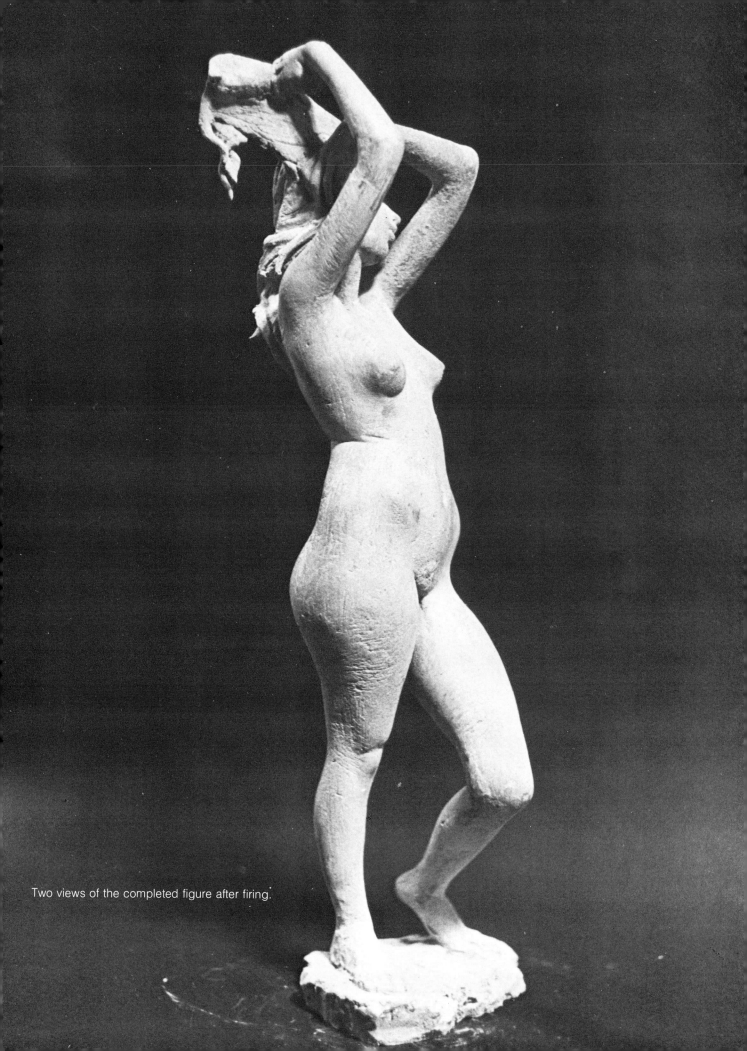

Two views of the completed figure after firing.

DEMONSTRATION TWO
SEATED FIGURE

In this demonstration an accessory is added to the figure—a chair. And because the figure is supported by the chair while it is being modeled, no further armature is necessary. Lucchesi has actually constructed a chair out of lengths of wire and a slab of plaster of paris, but he could also have built the figure on a block of wood and transferred it to a chair after it was fired.

This figure, like the standing figure in the previous demonstration, has a hollow torso and so must be pierced with vent holes before it is fired. The hole in this case is up from the bottom, and

it can be quite large as it will be hidden when the figure is seated. The upper legs, too, are hollow, so each thigh must be pierced from underneath where the holes won't show. The chair, of course, does not go into the kiln. The figure is removed from her seat, fired, and replaced, with a dab of epoxy between her bottom and the chair to keep her firmly anchored. Figure and chair may be further mounted on a sculpture base by affixing the chair legs and the toes of the right foot to the base with epoxy. (See under the heading "Epoxy" in *Tools and Materials* for details on how to handle epoxy glues.)

1. As he did with the standing figure in the first demonstration, Lucchesi forms a concave back for the torso. This he places on the chair.

2. Again as before, he fills the cavity with crumpled newspaper and closes the sides of the clay around it.

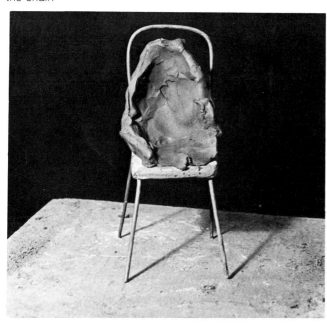

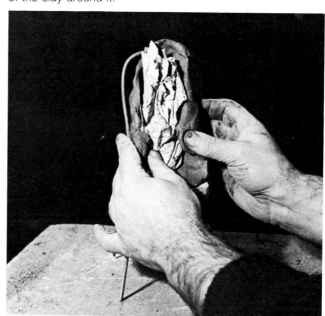

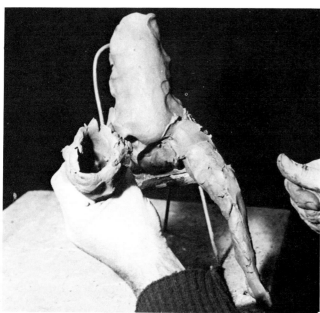

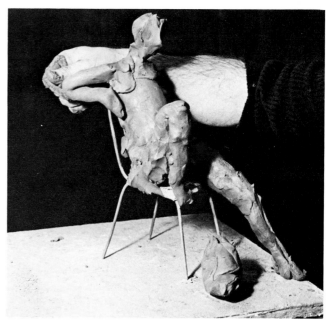

3. He has placed the front of the torso over the newspaper and worked the clay into the sides of the back. He now attaches the legs, which are formed from hollow tubes of clay.

4. Lucchesi has pinched in the top of the torso at the neck and added the head mass. Here he attaches an arm, which is a solid coil of clay melded into the clay of the shoulder with swipes of the thumb.

5. With a block scraper Lucchesi roughs in the basic planes of the figure, drawing the tool over the surface of the clay to remove the high points and fill in the hollows.

6. Now, holding a flexible steel palette in a curved position, he draws the tool firmly around the forms to define their fullness.

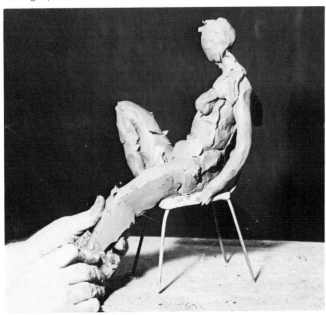

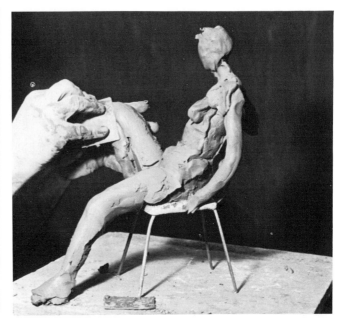

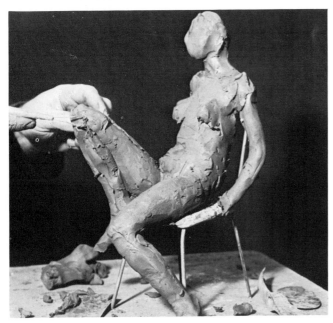

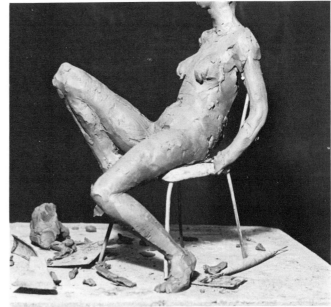

7. He has repositioned the outside leg. Now with a wire loop tool he carves out the musculature of the other leg.

8. He has gone over the rough carving and added clay to flesh out the forms. The knees are defined and the right leg has been tapered toward the ankle by shaving downward with the block scraper.

9. More carving with a wire loop tool. Lucchesi pulls it down the leg, drawing the forms as well as cutting away clay.

10. Now he indicates the dips and hollows of the body, here carving out the hollow between collarbone and arm. He has also drawn in the divisions of the front torso and placed the navel.

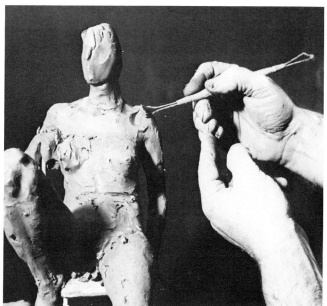

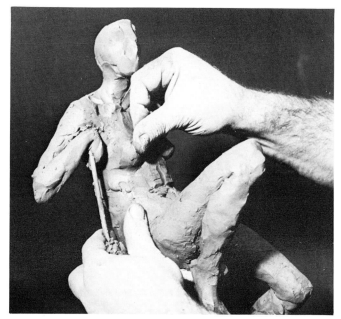

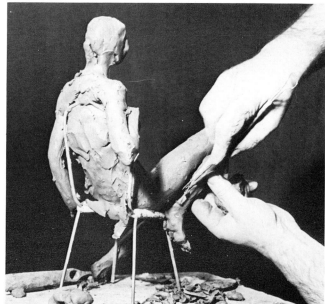

11. With his thumb Lucchesi rubs a pellet of clay onto the breast to form the nipple. This is typical handmodeling: quick touches of the thumb over the entire surface of the piece, each touch-carrying a small pellet of clay.

12. Back to the leg again, he uses a wire loop tool to cut into the area behind the anklebone and draws it up along the division between calf and thigh.

13. Lucchesi has placed the hand mass. Now he attaches coils of clay for the fingers, one by one. Even at this first stage the finger is bent at the center joint and the pad at the tip and the fingernail are indicated by the upturn at the end.

14. Moving up to the head, Lucchesi sweeps the clay up and out from the centerline with equal pressure from both thumbs. This ensures that the head will be evenly rounded on both sides.

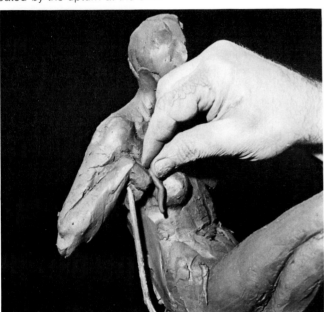

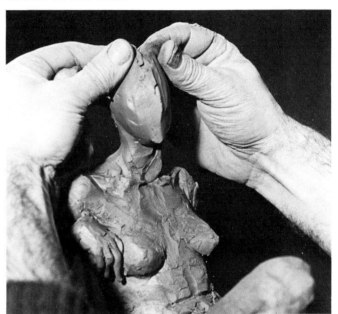

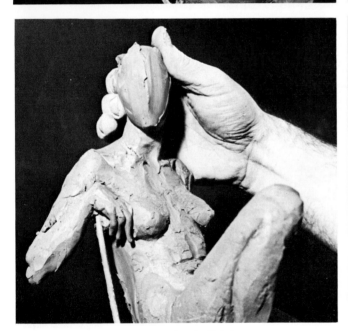

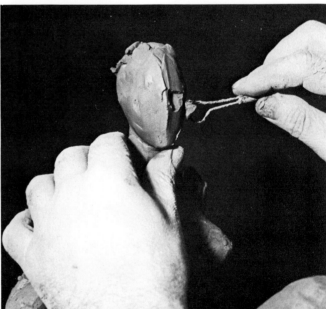

15. He positions the head, turning it slightly at the neck. Because there is no armature, the artist is free to play with the position of the head, arms, legs, and even the torso as he goes along.

16. Lucchesi defines the areas of the face with a wire loop tool. Here he gouges out the eye socket.

17. The face has been roughly sketched in. Lucchesi forms the temple and forehead area by sweeping back the clay with his thumbs to both sides of the head.

18. Eyes, nostrils, and lips have been defined and the back of the head has been formed. Here Lucchesi adds the ears.

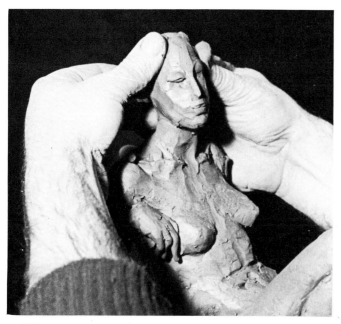

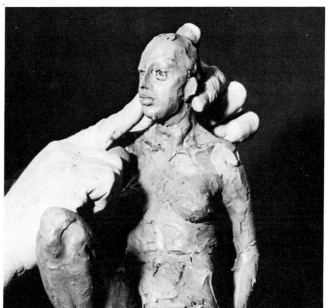

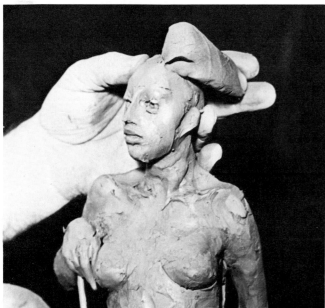

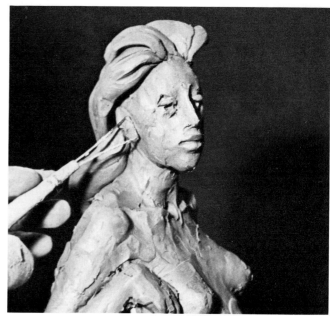

19. Lucchesi applies the hair in great coils, which gives the effect of the large masses in which hair really falls.

20. More hair has been added and the coils have been blended into each other with a modeling tool. Here Lucchesi uses a wire loop tool to draw the S shape of the ear.

21. Because there is no armature, forms that protrude may need propping up until they become firm enough to stay put. Lucchesi props one leg up with a modeling tool.

22. Another prop, this time under the arm. Here you can see more clearly how the coils of hair flow in large masses to make an overall pattern. The back of the figure is divided down the center, along the indentation of the spine, and the clay is worked out to each side.

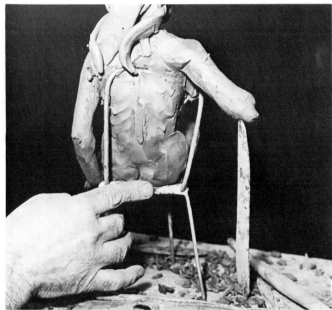

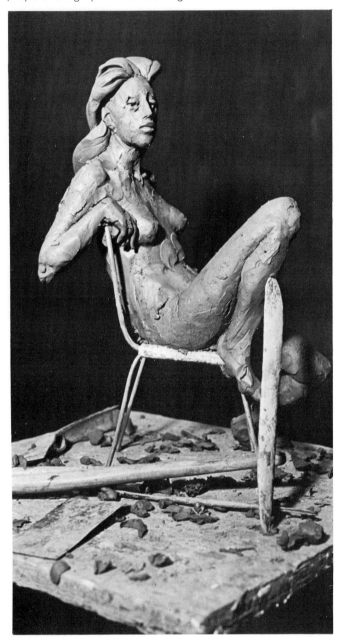

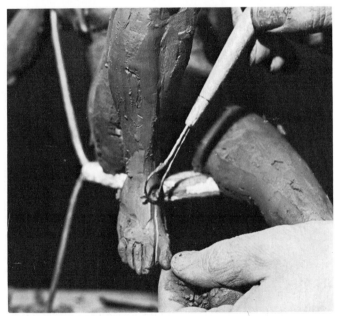

23. Lucchesi has divided the toe mass into individual toes. Notice the gap between the big toe and the other toes: the big toe operates singly and the other toes operate together, as a unit. Notice, too, that the toes are not straight. Like the fingers, they bend at the center joint and there's a slight upturn at the end where there's a pad underneath and a toenail on top. Here Lucchesi runs the line made by the tendon of the big toe up the foot. This line is a visual continuation of the indentation that runs up the leg dividing the calf muscle and the shinbone.

24. Here we see the bend of the toes more clearly. Notice how the anklebone protrudes and how the flesh bulges as the upper and lower parts of the leg squeeze together.

25. Lucchesi runs a flexible palette over the surface to blend the clay and define the forms.

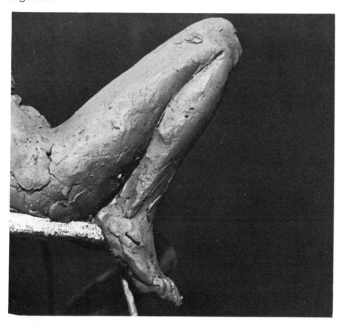

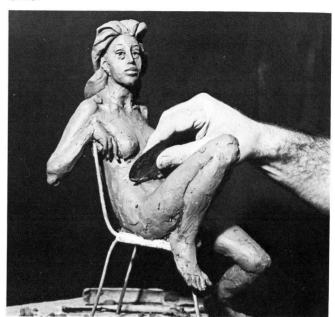

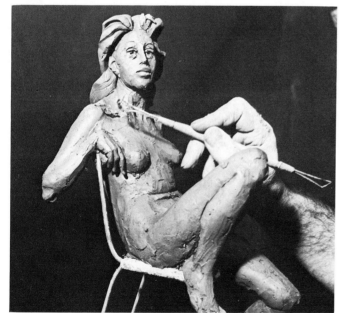

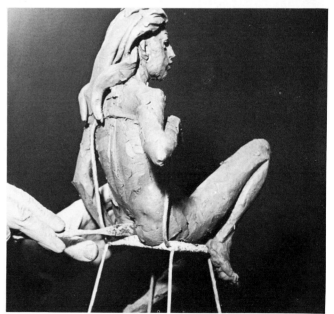

26. He reemphasizes the dips and hollows of the body with a wire loop tool.

27. With a flat plaster tool he emphasizes the cleavage of the buttocks, which is accentuated by their being pressed against the seat of the chair. The spine protrudes slightly because the figure is arched forward.

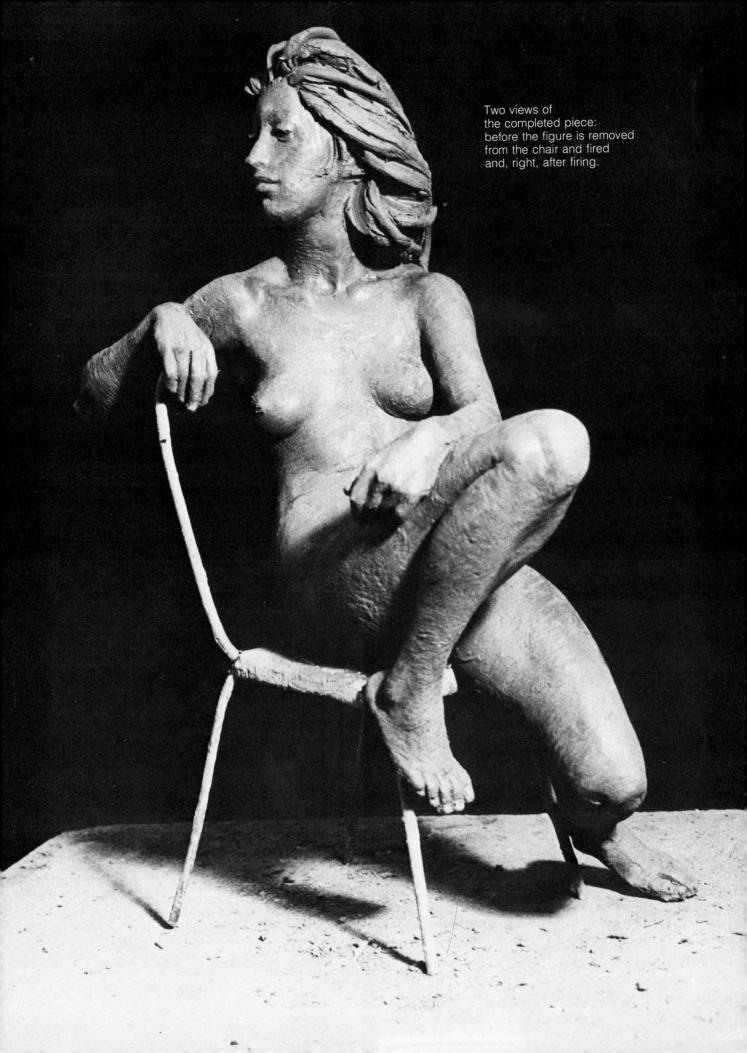

Two views of
the completed piece:
before the figure is removed
from the chair and fired
and, right, after firing.

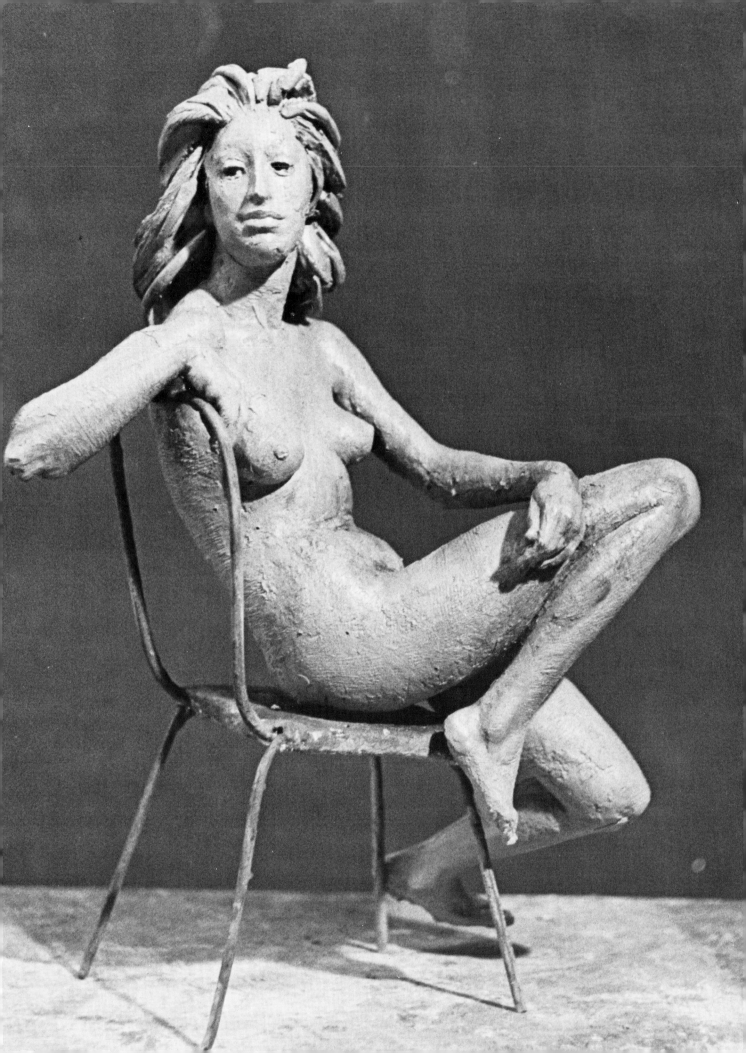

DEMONSTRATION THREE
RECLINING FIGURE

A reclining figure, if small, may be built and fired solid; it may be built solid and hollowed out from underneath before firing; or, as in the two previous demonstrations, it may be built over a newspaper core which will burn out during firing. Whether it is solid or open at the bottom, it needs no vent holes.

Lucchesi places his reclining figure on a bed of cushions built over a foam-rubber core so that he'll feel a lifelike "give" while he works. This foam-rubber core must, of course, be removed before the piece is fired. Unlike newspaper, which burns out with only a little smoke, synthetic materials give off fumes that are hazardous to breathe.

After firing, this piece was mounted on a sculpture base in a slanted position to accentuate the light, airy effect of the cushions. This necessitated drilling a hole in the fired terracotta with a masonry (carbide-tipped) bit and running an iron rod into the sculpture and anchoring it in the base. The two ends of the rod are secured with epoxy.

1. Lucchesi uses a chunk of foam rubber as a support for his figure. It provides a soft "give" that makes modeling on top of it realistic, like working on a pillow.

2. He wraps the foam rubber in newspaper to keep the clay off the foam and to make it easier to remove later.

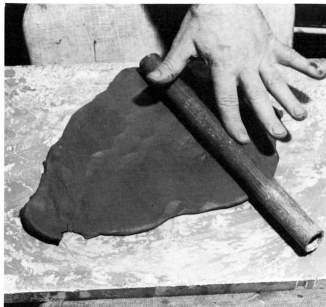

3. Lucchesi uses a length of pipe to roll out a ball of clay until it forms a flat slab or "sheet."

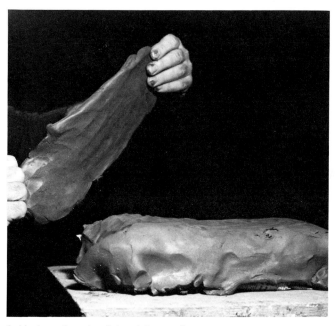

4. He lays the clay "sheets" over the bed. It takes several to fully cover the form.

5. Now Lucchesi starts to place the figure on the bed. At this stage the body is the clay equivalent to a stick figure in drawing: the torso is a solid hunk of clay and the leg is a coil bent at the knee.

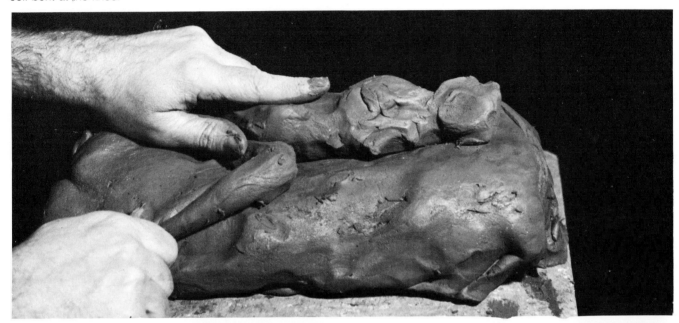

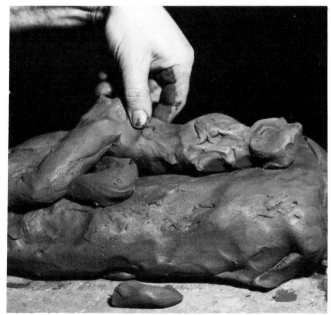

6. He works the legs into the torso with pushing movements of his thumb.

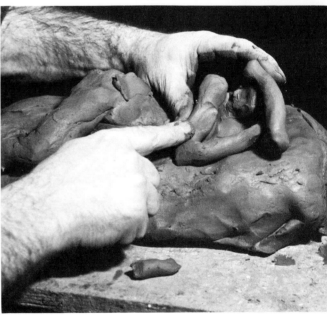

7. Now he adds the arms, indicating the musculature of the upper arm.

8. Lucchesi fleshes out his stick figure, here placing a flat slab of clay over the hip and buttock area.

9. Now, with a flexible steel palette, he blends the forms of the body, bending the tool so that it moves around the forms.

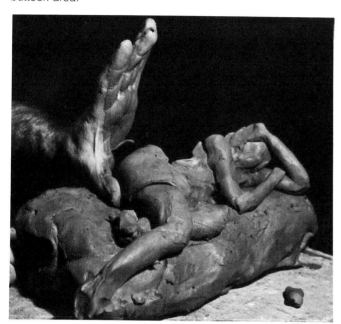

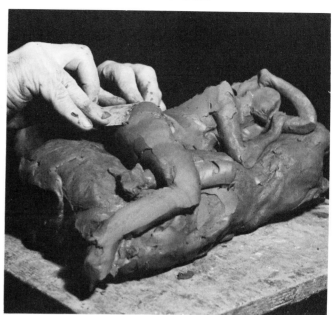

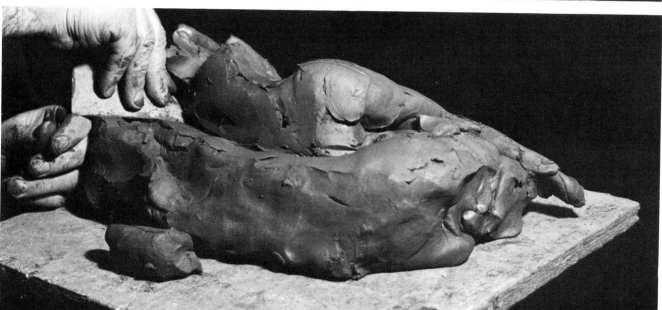

10. He moves the tool around to the back, blending the forms there and using the edge to undercut between the body and the bed.

11. Now he begins the finer modeling, working with his fingers and with a plaster tool, which he uses to cut around the forms.

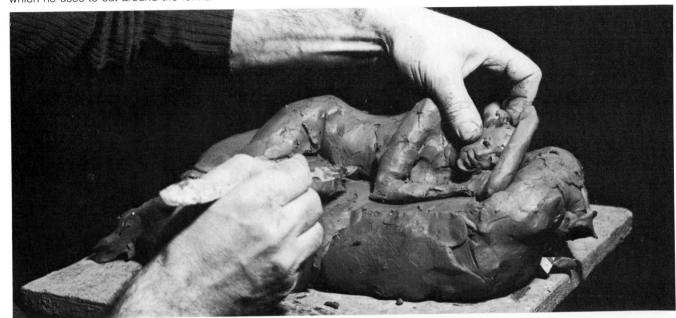

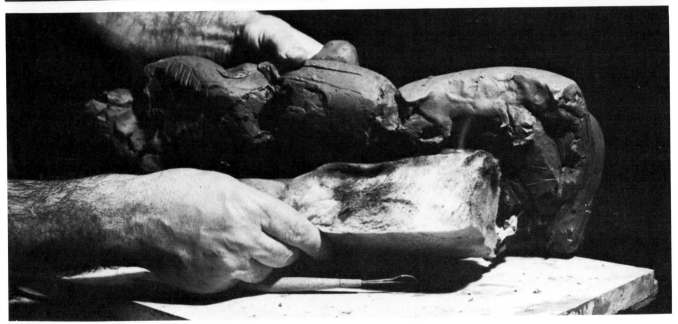

12. At this point the modeling is completed sufficiently to remove the foam-rubber core.

13. The newspaper is also removed and the space is hollowed out still further with a wire loop tool.

14. Now the bed is hollow, so Lucchesi bends and forms it carefully until he gets an angle and sense of fullness that please him.

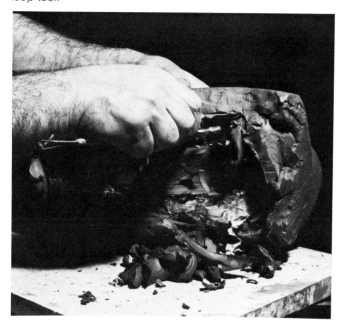

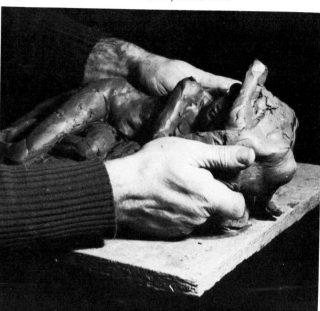

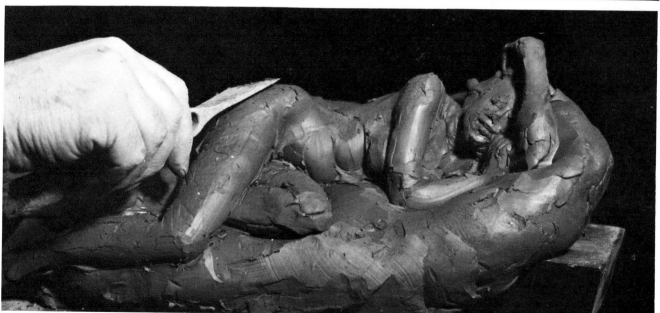

15. He uses a pick-ax head to slap the clay into strong planes. He could also use a piece of wood, the back of a scrub brush, or the heel of his hand for this purpose. He has propped the bed up with a chunk of wood to keep it at an interesting angle.

16. Lucchesi draws a flexible steel palette, held in a curved position, over the bed, front and back, to give it a soft, round contour.

17. From contouring the bed he goes to contouring the figure. He draws the palette, still curved, around the legs and buttocks, working always in the direction of the curve.

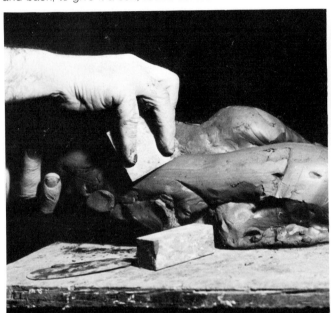

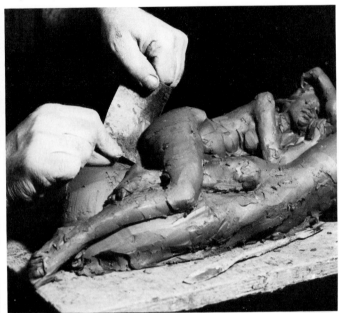

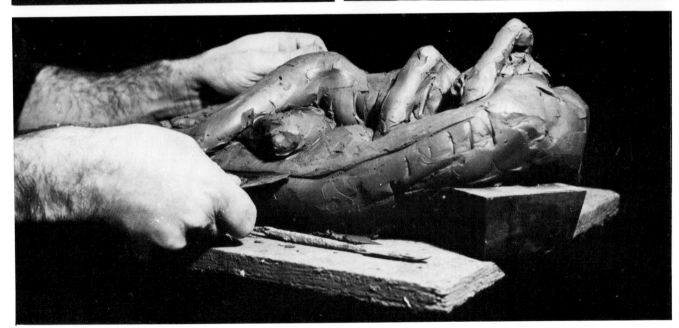

18. To give the bed a more mattresslike appearance, Lucchesi incises a centerline all around with an oval steel palette.

19. He adds fullness to the figure by dabbing on bits of clay and rubbing them in.

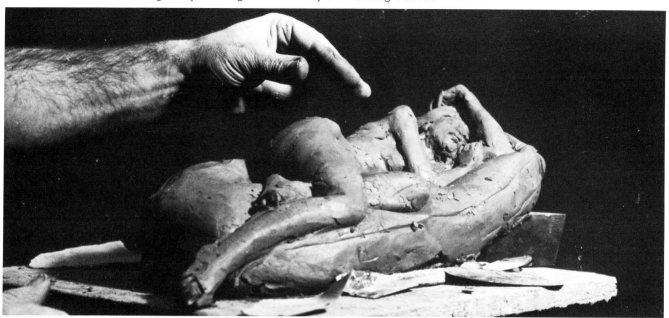

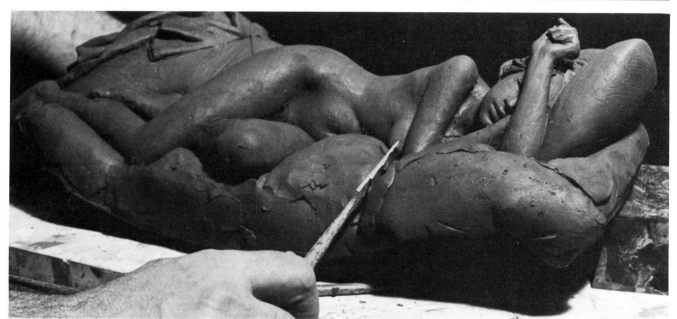

20. Lucchesi decides that the bed would work better with the figure if he divided it into individual cushions. He uses a large plaster tool to carve into the solid shape. He has also thrown a bit of clothing onto the foot of the bed for added interest.

21. In this view of the clothing you can see how it is formed. Lucchesi slaps or throws a slab of clay on his worktable or on the floor until it is quite thin, then he cuts the edges all around to get rid of any raggedness. When he has prepared his piece of "cloth" he simply drapes it, almost letting it fall as it will, where he wants it. The folds that the thin clay naturally makes are more believable than any that could be contrived. Once the folds are there, they can be worked into the rest of the piece.

22. With a plaster tool Lucchesi cleans out and accentuates the junction of back and cushions. It's important when modeling two plump forms that meet that each appears to be pushed out by the other. In other words, at their fullest points the two forms spread out and become even more full through the mutual pressure.

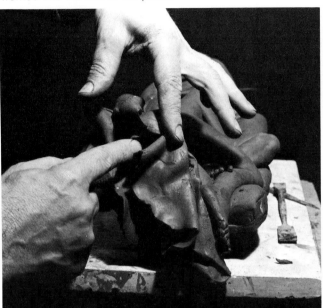

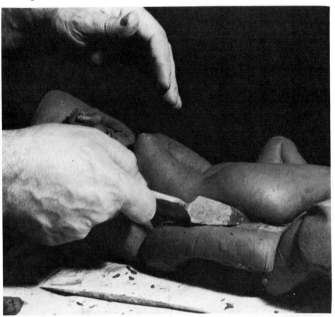

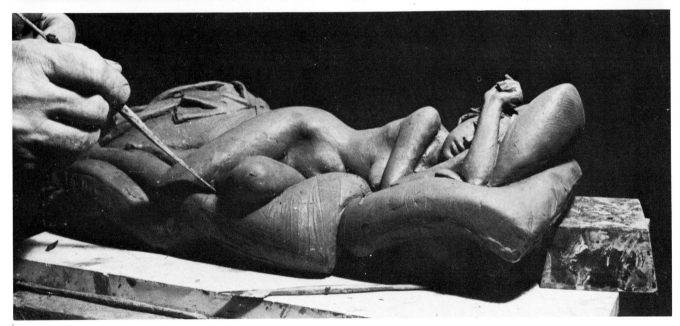

23. Here the modeling of full form pressing into full form can be seen even more clearly, not only in the body against the cushions but in each cushion in relationship to its neighbor. Lucchesi digs around the forms with a thin plaster tool to clearly divide the forms and accentuate their fullness.

24. The modeling is complete and now Lucchesi goes over the entire surface with a wet paintbrush to get a smooth, even texture.

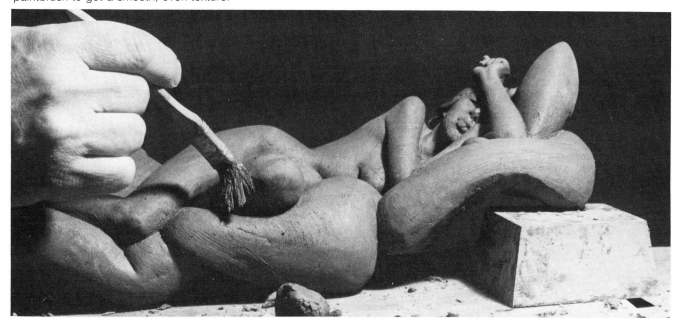

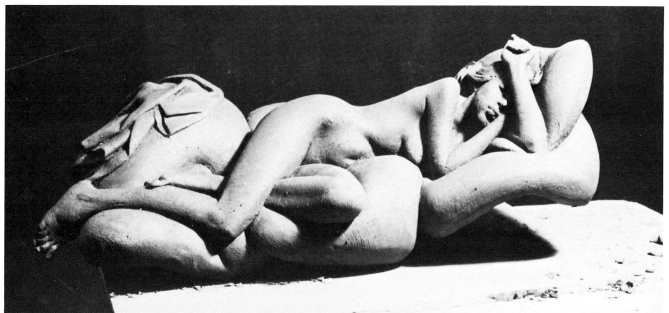

25. When gone over with water the details and divisions tend to fill in and become blurred. Here they have been reestablished. To get from this stage to the completed piece consists of repeated water brushings followed by redefinition of detail until the perfect balance of soft fullness of form and crisp articulation is reached.

The completed piece after firing,
propped up to the angle
at which it will be mounted.

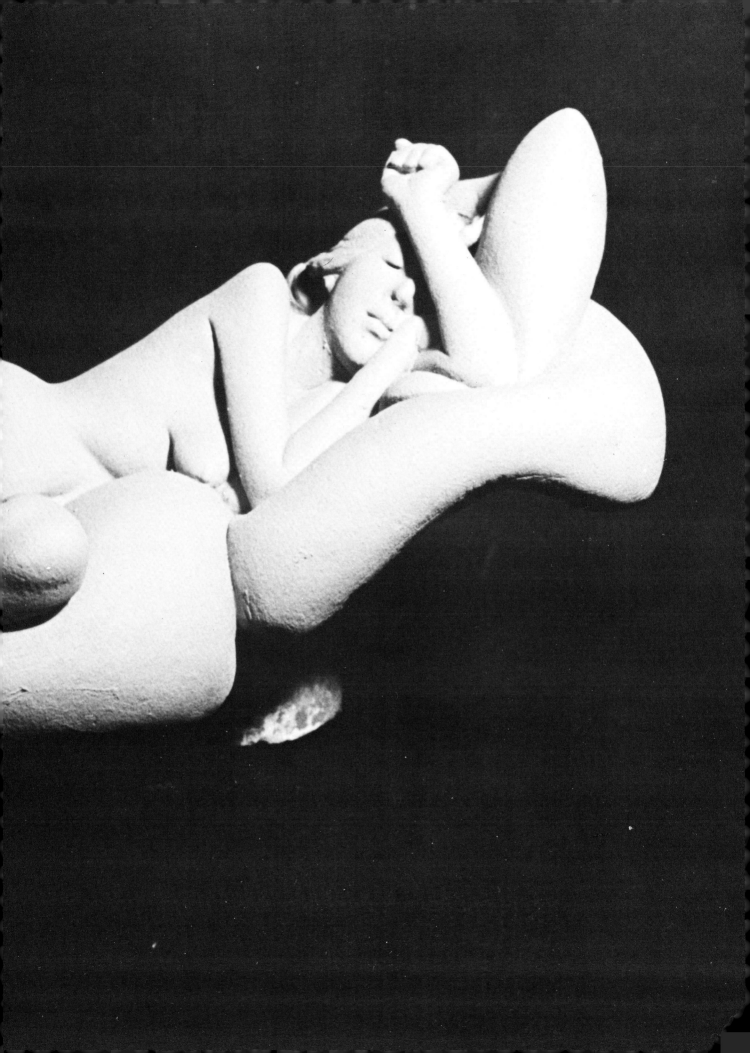

DEMONSTRATION FOUR
BAS-RELIEF

A bas-relief presents a special challenge to the sculptor, for here the elements of drawing and painting—that is, illusion—are used in conjunction with sculpture in the round. A bas-relief is a sculpture that is built up on or carved into a flat surface. The image may protrude only a little or it may be almost three-dimensional, attached to the surface by a hairsbreadth. Part of the relief may be deep while another part may be shallow, merely drawn in. Also, a relief usually implies a larger composition, a space within which the figure or group of figures moves. So the sculptor must give life not only to the figure in a bas-relief but to the surrounding space as well.

When he works on a relief Lucchesi sometimes works flat, with his support board lying on a table, and sometimes with the support propped up at an angle. In the early stages of composition and modeling it's a good idea to work at an upright angle so that the proportions won't be distorted when the piece is finished and viewed hung on a wall. To keep the clay from sliding down the support when you prop it up, clamp or nail a narrow strip of wood along its bottom edge for the clay to rest against. For the support use only wood or Masonite, never Plex-iglas or other synthetics as the clay will stick like glue, cracking as it dries and not letting go of the support when you want to remove the piece for firing. The clay will stick to wood and Masonite, too, of course, but not so tenaciously. A good way to cut down on the sticking problem is to sprinkle the surface lightly with sand before laying down the clay; or you can cover the support with a sheet of plastic wrapping or even tinfoil.

This relief is built solid and so it needs no vent holes. A thick relief—or any relief that might possibly contain trapped air pockets—should be hollowed out from behind. After a relief is fired it may be hung on the wall as is or it may be mounted first. If you want to hang a relief directly, simply affix a length of picture-hanging wire to the back with epoxy. Make sure, however, that you secure the wire to the back in several places, not just two, in order to distribute the pull over a large area. Otherwise the weight of the terracotta could cause the epoxy to rip a whole flat section off the back. If you run the wire in a circle, attaching it with generous blobs of epoxy at frequent intervals, you shouldn't have any problem.

1. First, Lucchesi spreads a covering of clay over his board, scraping the surface to an even thickness with a large block scraper.

2. He has drawn his figure into the surface with a sharp-ended modeling tool. Now he fills in the outlines with clay.

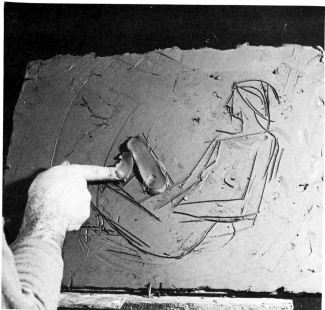

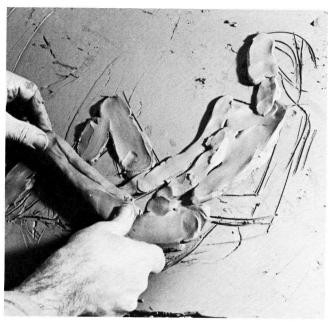

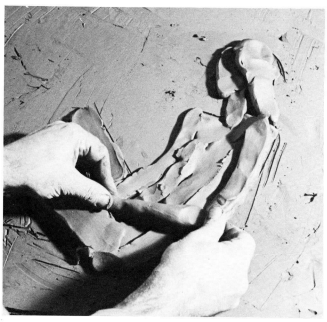

3. More filling in. Notice that the parts of the figure closer to the viewer protrude more from the surface than those in the background.

4. He adds the hair and the near arm. The method of adding clay is to roll a coil, position it, then press it against the clay of the surface with a pushing sweep of the thumb.

5. Lucchesi smooths and blends the forms with a swipe of the heel of his hand. He has roughed in some cushions against which the figure will recline.

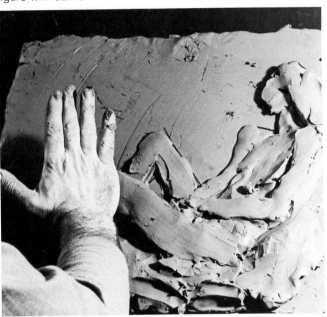

6. Lucchesi begins to model the face: he builds up a nose, gouges out a socket for the eye, and smooths the forehead.

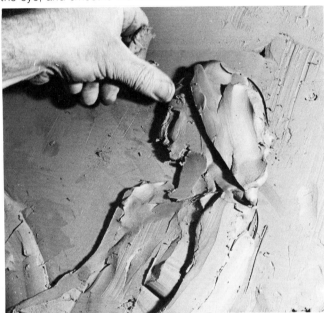

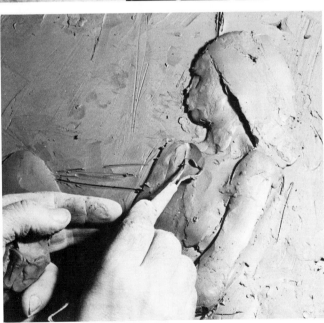

7. With a wire loop tool, he indicates the hollow of the shoulder between collarbone and arm. Behind the figure he has drawn in the outline of a window.

8. Now, with a flexible steel palette Lucchesi smooths and blends, curving the tool around the form as he works.

9. Lucchesi has made the window behind the figure smaller and has started to build up a wall at her back. For this, he slaps down flat slabs of clay and works them into the underclay with sweeps of his fingers.

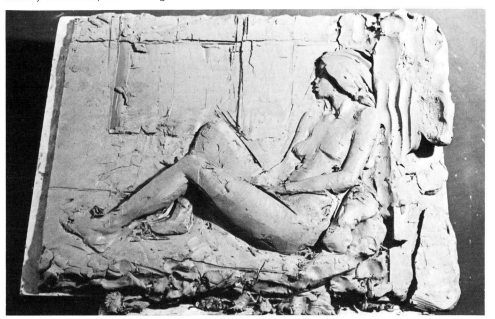

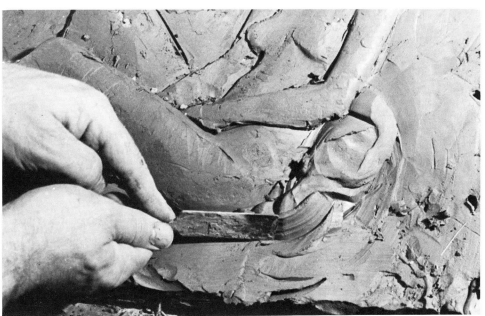

10. Here Lucchesi uses a flat plaster tool to carve and shape the pillows. As always, he moves the tool in the direction he wants the forms to take.

11. This side view shows how far the relief actually protrudes from the surface. Some of the roundness, as in the foreground leg and arm, is real; some of it, as in the torso, is partly an illusion; some is arrested midway, as in the face; and some is simply drawn, as in the window.

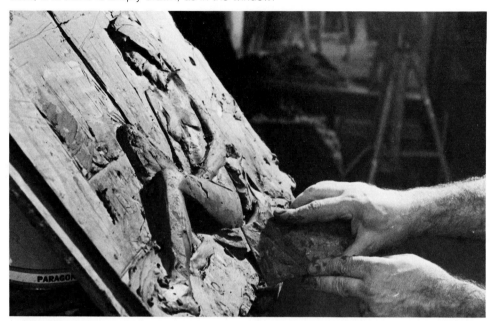

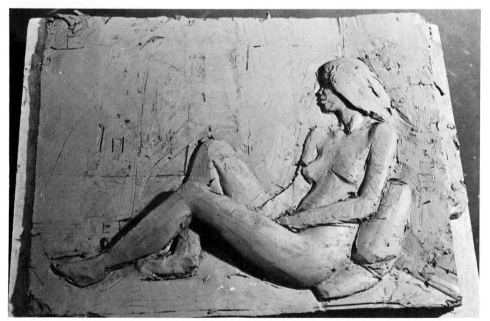

12. As he works, Lucchesi constantly rethinks his composition. He has erased the window with a swipe of the block scraper and has smoothed the wall at the figure's back. Notice the perspective line at lower right. This is the floor line, which runs back to meet the wall line behind the figure's head.

13. Lucchesi uses the wooden back of this scrub brush to slap clay into broad planes; he uses the bristle part, as shown here, to blend the clay. This blending, done either with a wet brush or dry, serves to dissolve the bumps and hollows as well as impart an overall surface texture to the piece. This makes it easier for the sculptor to see the actual ins and outs of the sculpture without being distracted by imperfections in the surface.

14. More blending and smoothing, this time with a dry towel. This serves the same purpose as the rougher brush blending, but of course it imparts a finer surface.

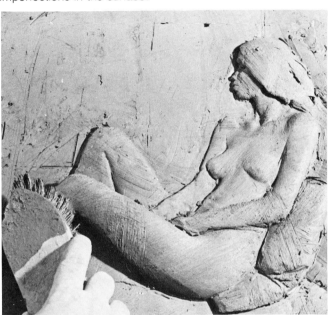

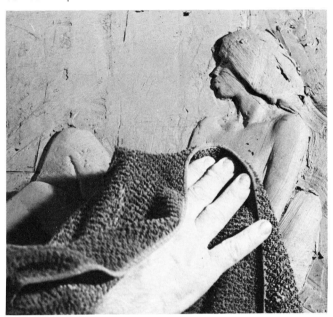

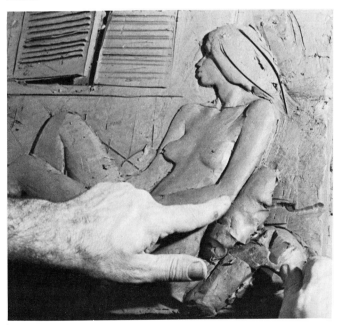

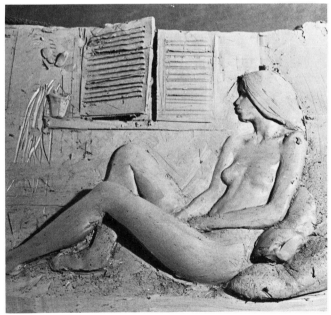

15. With a flat plaster tool Lucchesi has drawn in the large pattern of the hair, made shutters on the window (which has been reinstated), and is carving the pillows. Notice how he inserts the tool underneath the pillow and actually lifts the clay up and out to plump the form. He exerts pressure from the top with his forefinger so that it's only the pillow that plumps and not the entire right side of the piece. The shutter at left was pulled out in the same way: first it was drawn in with a pointed modeling tool, then it was undercut and pulled out until it became three-dimensional.

16. You can see the marks of more blending with a dry scrub brush at right, especially over the pillows. A flowerpot has appeared on the windowledge.

17. Lucchesi has added details to the feet, including the toes, has cut folds into the pillows and furrows into the hair, and has gone over the entire surface, smoothing and blending, which has erased the flowerpot a bit.

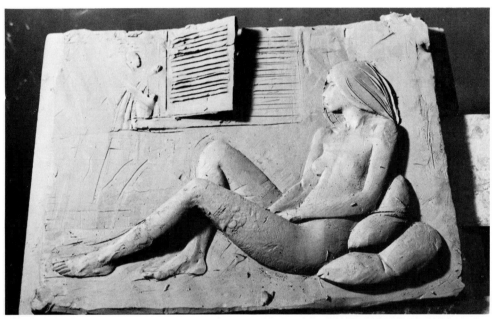

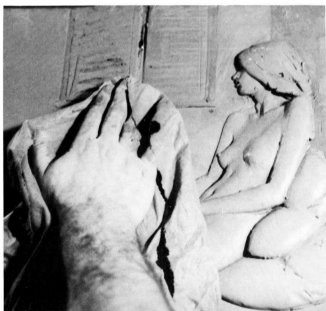

18. Here Lucchesi wipes the surface with a wet cloth. This further blends and refines the surface. The flowerpot has disappeared entirely.

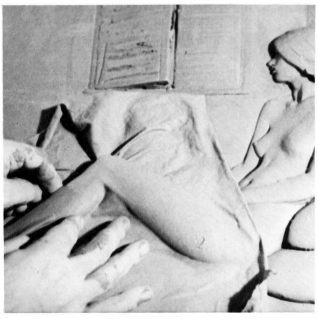

19. The wet cloth is also used to refine the modeling. Lucchesi dips it in water, slaps it onto the surface, and works it around the forms, gently pressing and smoothing through the material with his hand. He also works a wet brush through a cloth to the same effect.

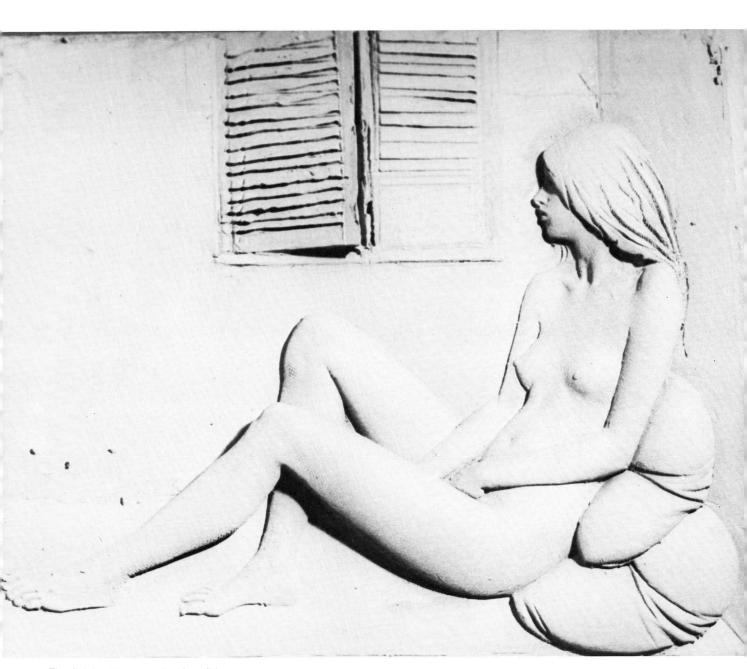

The finished bas-relief before firing.

DEMONSTRATION FIVE
PORTRAIT HEAD

For this demonstration Lucchesi uses a lifesize 18″ (45.7 cm) head armature, available in any art supply store that carries sculpture materials. The head is built over a paper core so that it will be hollow, and it's open at the bottom so that it won't need vent holes. When it is completed Lucchesi slits it in half, removes the two halves from the armature and hollows them out still more, then "glues" them back together again with slip. To make the paper core Lucchesi packs crumpled newspaper into the wire "egg" of the armature, wraps more newspaper around the outside, and covers the newspaper with a paper bag. The newspaper is packed firmly and covered so that when it absorbs water from the clay and becomes soggy it won't shred and come apart. It's a good idea when constructing a head in this way to also prop the clay up from below, underneath the neck or shoulders, even under the chin if the face starts to sag or crack. When the rough modeling is completed allow the clay to dry out a bit to strengthen the clay wall and make it better able to withstand the pull of its own weight.

When modeling a face Lucchesi follows a basic procedure. First he slaps a masklike slab of clay onto the head mass to form the surface of the face. Then he divides this down the middle, sweeping the clay back from the midline. He gouges out an area on each side of the midline for the eye sockets and adds clay for the nose, the protruding mouth area, and the chin.

The lips themselves are made up of three balls of clay for the upper lip and two for the lower (see Step 7). Two more balls of clay are placed into the eye sockets to become the eyes. The eyelids are rolls of clay draped over these balls, top and bottom. Another ball of clay becomes the fatty protuberance at the end of the nose, two more form the nostrils, and another defines the jutting roundness of the chin. These balls are of course worked into the surrounding clay so that their original roundness is lost.

Hair is not added until the head and face are well defined. It's difficult to model the sweep of the cheekbones or the contour of the brow if there's hair in the way. Lucchesi attaches the hair to the skull in great "snakes," coiling and twisting it to fall in masses. In this way the hair has as much weight and substance as the rest of the piece; it's not merely a covering for the head but a sculptural form in itself.

This portrait head was not brought to a highly finished stage. It is fully modeled but not textured or refined. The purpose here is to show how the features of the face and the hair are modeled. You could, of course, apply the fine modeling techniques shown in the next two demonstrations to achieve a polished portrait.

A head, like the reclining figure in Demonstration 3, must be mounted with an iron rod to attach the terracotta to the base. For the best results this kind of mounting should be left to a professional. (See *Suppliers* at the back of this book for places to get your work mounted.)

1. Lucchesi fills the hollow of a lifesize head armature with crumpled newspaper.

2. He covers the newspaper with a paper bag, twisting it around the shank of the armature to keep the newspaper in place.

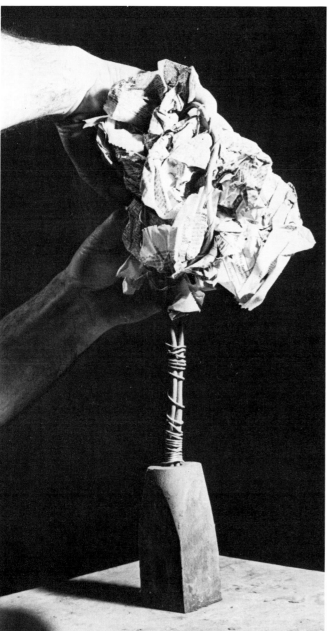

3. Now he covers the paper bag with large slabs of clay, wrapping another slab around the shank to form the neck.

4. He packs the clay around the paper firmly and works it upward with sweeps of his hand. He places a masklike slab of clay over the head mass to form the surface of the face.

5. Now he roughly indicates the features—the eye sockets, nose, lips, chin—as well as a suggestion of the hair mass.

6. He adds the left ear, marks the features more fully, indicates the eyebrows, and places the round ball-like protrusions of the lips and chin.

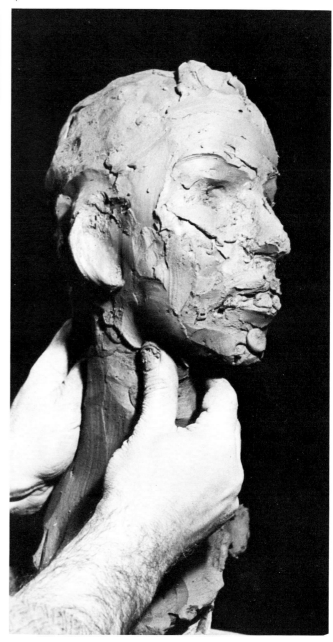

7. He uses a wire tool to dig into the ear cavity.

8. With a wire tool he further defines the S shape of the inner ear and adds the fatty earlobe.

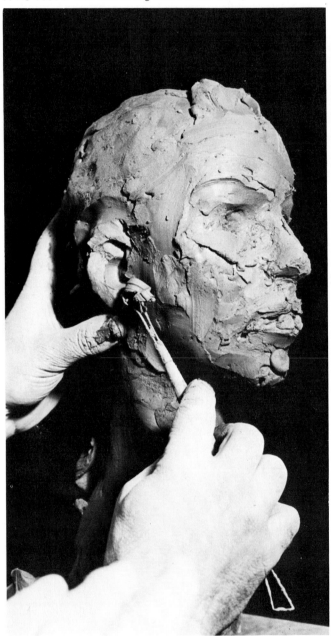

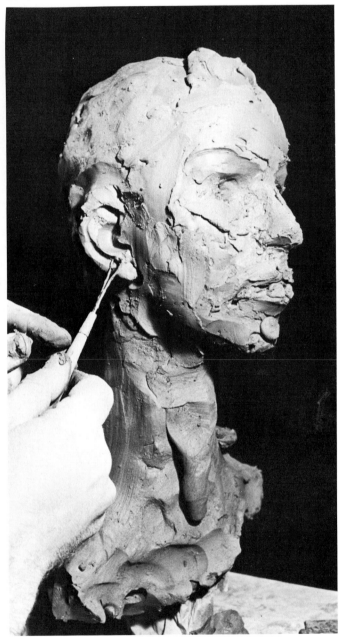

9. Now he models the ear itself, pushing it out from the head.

10. Again using the wire tool Lucchesi digs out the cavities of the nostrils.

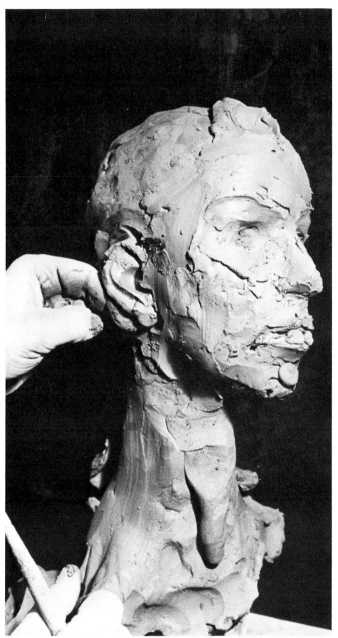

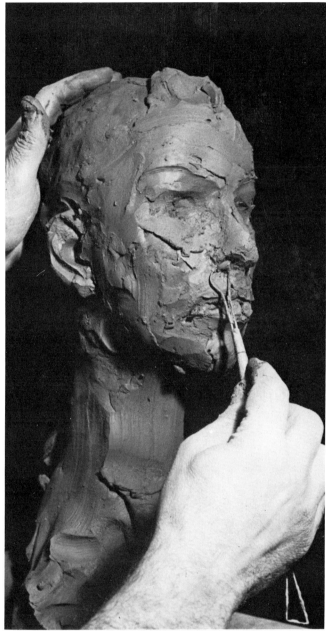

11. The "marble" of the eyeball is placed into the eye socket and the upper eyelid is laid over it. A similar lid will be placed at the bottom.

12. The eyeball and eyelids have been worked into the clay of the surrounding area and here Lucchesi digs out clay to form the iris and pupil.

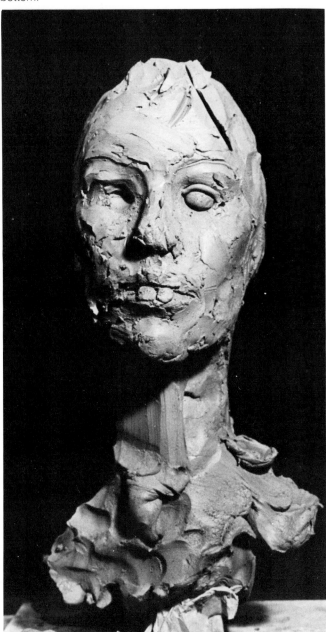

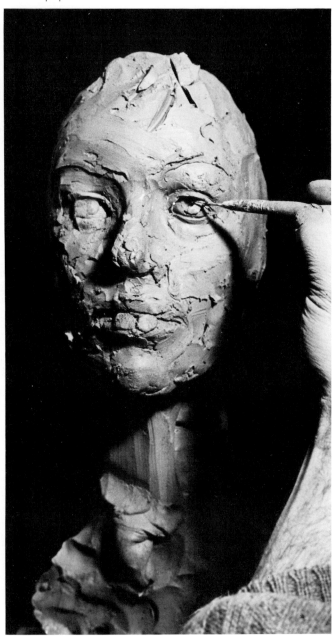

13. The darks of the eyes are indicated by a spiral stroke rather than being "holes" in the eyeball. This catches the light in such a way as to separate the iris from the darker pupil. Lucchesi has blended the balls of clay on the lower lip and added more hair as well as the right ear mass.

14. Here Lucchesi checks the placement of the ear by drawing lines straight back from the eyebrows and the bottom of the nose. The darks of the eyes have been obliterated by further modeling.

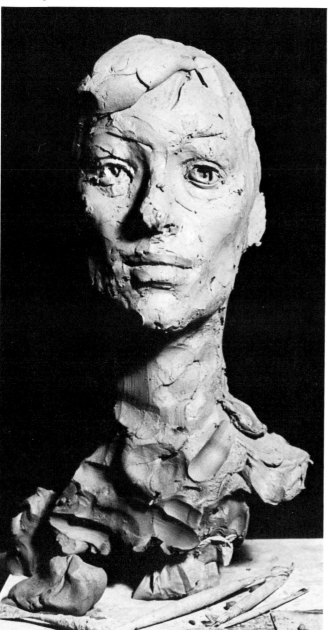

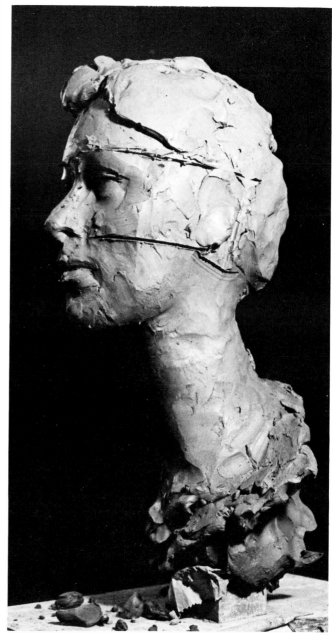

15. He uses a piece of cardboard to blot texture into the skin and help model the round forms of the cheekbones, jaws, and chin.

16. A pair of calipers helps determine if the proportions of the portrait match those of the sitter. The calipers Lucchesi is using here are very large; a smaller pair, say 10″ (25.4 cm), would do.

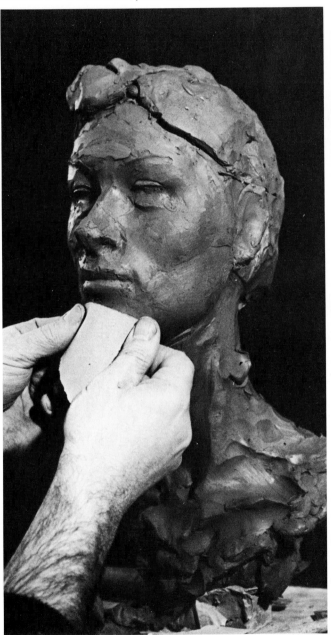

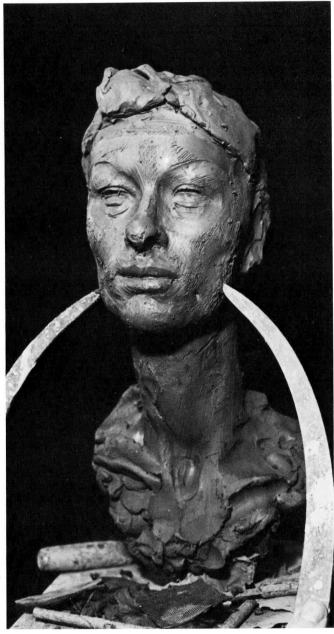

17. Lucchesi uses a flexible steel palette to smooth and round the surface and to nick out the fine lines of the lips.

18. He opens up and smooths the inside of the nostrils with a modeling tool.

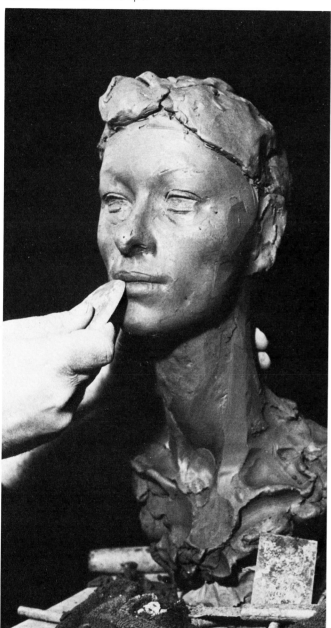

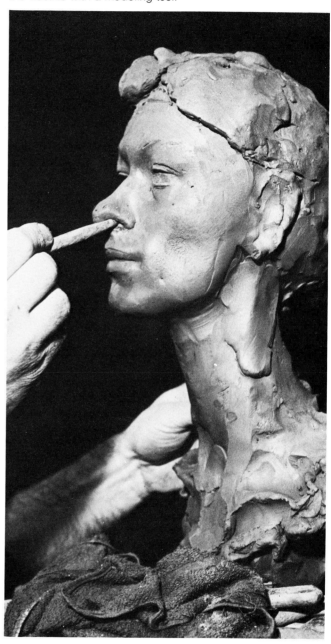

19. The darks of the eyes are again indicated and Lucchesi adds the hair mass, slapping the clay into place with the back of a scrub brush.

20. He presses the edge of the scrub brush into the clay and draws it sharply down to sketch in the hair forms.

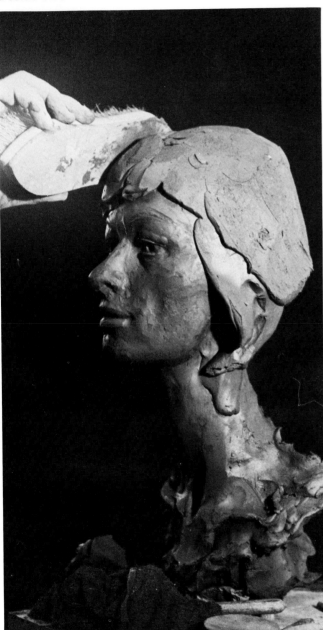

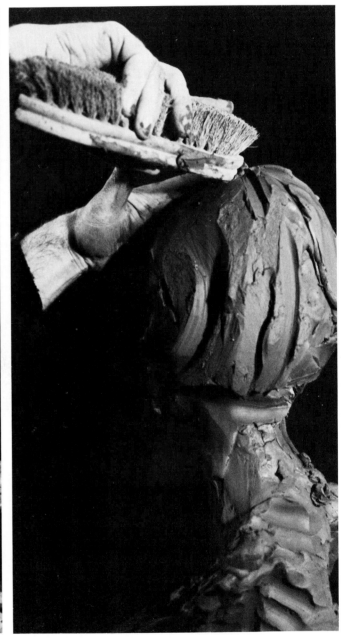

21. He draws a block scraper down over the surface, digging in with the edge to more sharply define the masses of hair.

22. Now he draws the scraper firmly down the hair and neck at the back, curving and pushing the tool to indicate the contour.

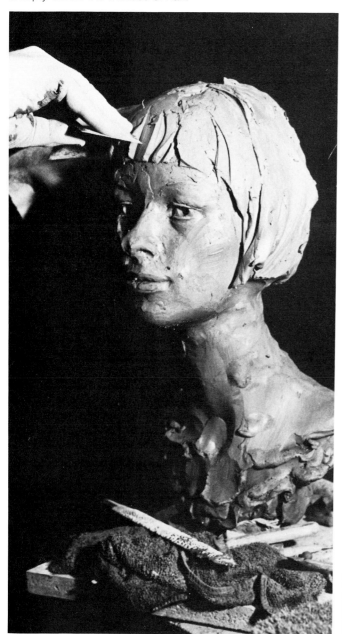

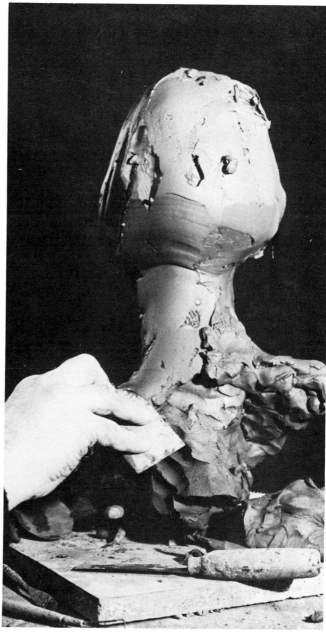

23. The head is ready to be removed from the armature: it's completely modeled but the surface is not finely detailed or textured. Lucchesi slices the head in half with a sharp plaster tool.

24. He gently works the halves off the armature.

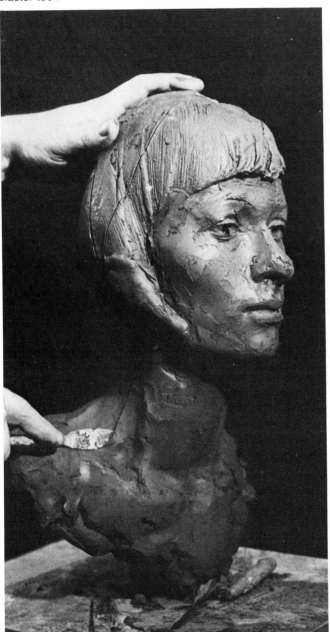

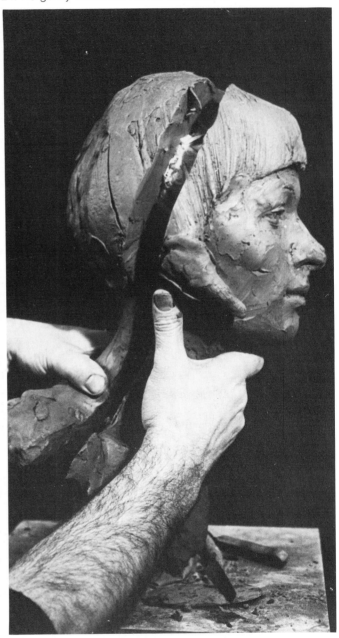

25. He scoops clay out of both halves with a large wire loop tool until the clay wall is about 1″ (2.5 cm) thick. He then scores the edge of the back half with his wire tool so that the slip (see next step) will adhere more strongly and form a firm bond.

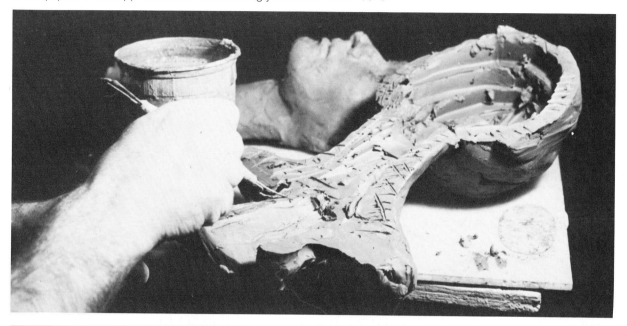

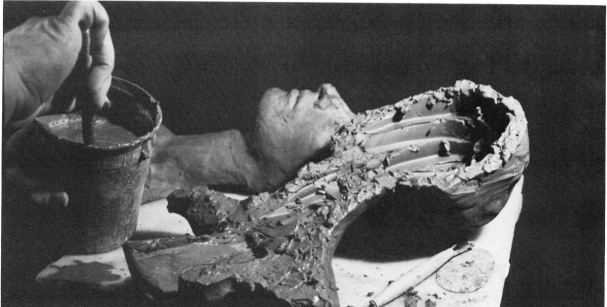

26. He applies slip to the scored edge.

27. He gently places the front of the head on the prepared back and works it well into the slip. After "gluing" the halves together he works over the seam on the outside until it is obliterated. The now-hollow head should remain lying on its back until the seam has healed. When the bond is strong enough the head may be placed upright again for further work on a simple support consisting of a stake attached to a base. However the head should also be supported from below, under the neck or shoulders, so that the full weight of the piece is not on the stake. Otherwise the pull of gravity can cause the top of the stake to force open the seam and the two halves of the head will break away from each other.

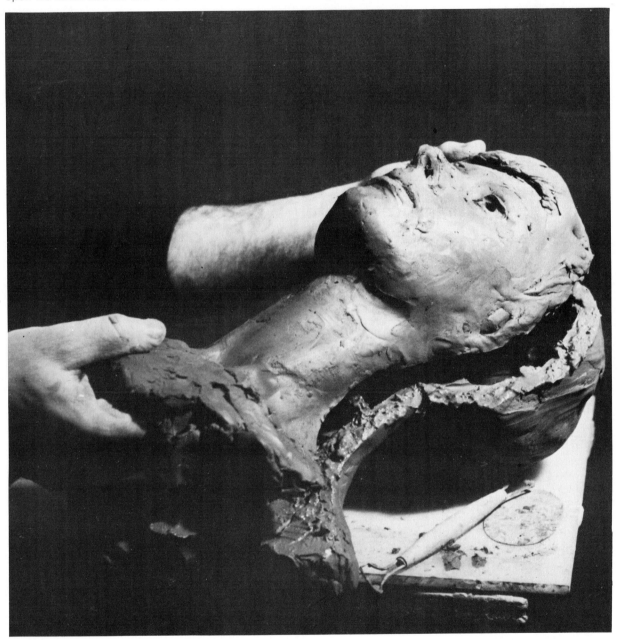

28. (Right) The completed portrait head could be left in this state of rough modeling, or it could be brought to a higher degree of finish by applying the techniques shown in the two demonstrations that follow.

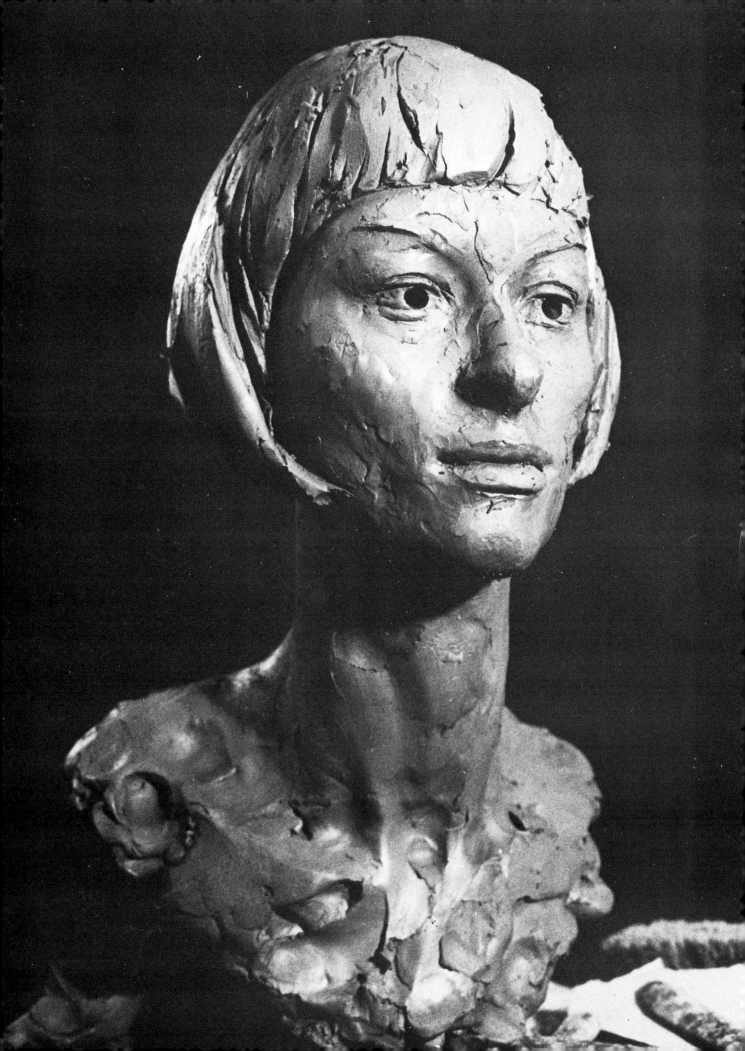

DEMONSTRATION SIX
FEMALE TORSO

For this large torso, about 20″ (50.8 cm) high, Lucchesi uses the same armature he used for the standing figure in Demonstration 1. But he covers it with newspaper topped by a plastic bag. When the piece is completed but still wet Lucchesi slits it in half, as he did the head in the previous demonstration, removes the two halves from the armature and hollows them out still more, then "glues" them back together again with slip. The body must be pierced with vent holes through the nipples and the navel, since after the halves are put back together again the hollow inner core is sealed off. The arms and legs are also built hollow, out of rolled cylinders of clay, and so must be pierced in unobtrusive places.

In this demonstration and in the one that follows you'll see in detail how Lucchesi works over the surface of a piece to finally attain the smooth yet textured look of flesh. The sequence of photographs represents only a fraction of the actual steps along the way, but to show every movement would have been impossible. It also would have been repetitive, since the basic process is one of building up then carving away, texturing then smoothing over, establishing guidelines then obliterating them with new modeling, over and over again, around and around the figure, so that the same procedure can take place hundreds of times. We've tried to show every important technique at least once; in what order you apply these techniques to your own work, and to what effect, is up to you. But you'll notice that, predictably, Lucchesi proceeds from rough to smooth, from rougher tools to finer, moving steadily toward a uniform, refined surface all around.

1. Lucchesi wraps newspaper around the armature. Over this he places a plastic bag (he could also have used a paper bag), twisting it closed around the armature pipe.

2. He has rolled out a flat slab of clay with a length of iron pipe. Here he bends the slab to make it easier to wrap around the covered armature.

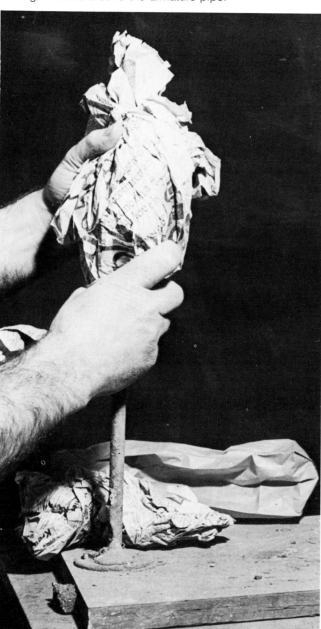

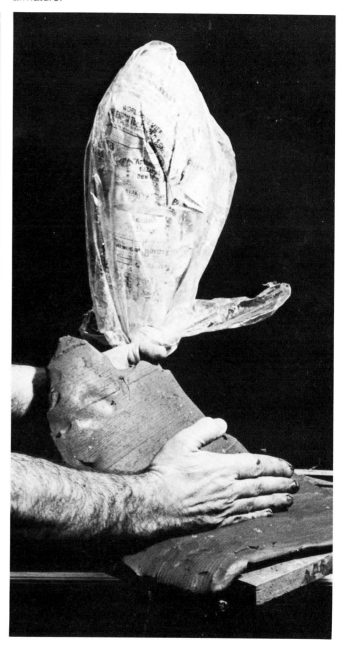

3. He wraps the clay slab around the paper core, pressing it in tightly all around to produce a firm working surface without excess air inside.

4. He has added another slab of clay to the back. A third slab of clay has been rolled out, and from this Lucchesi cuts enough to form a hollow leg.

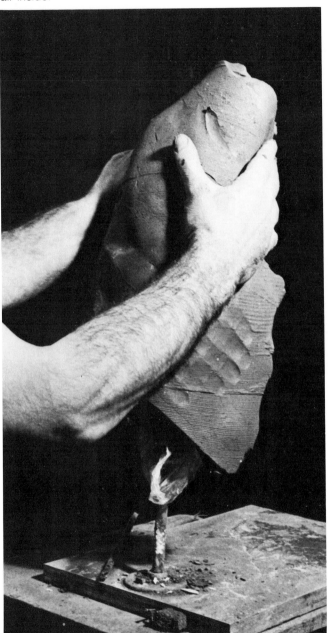

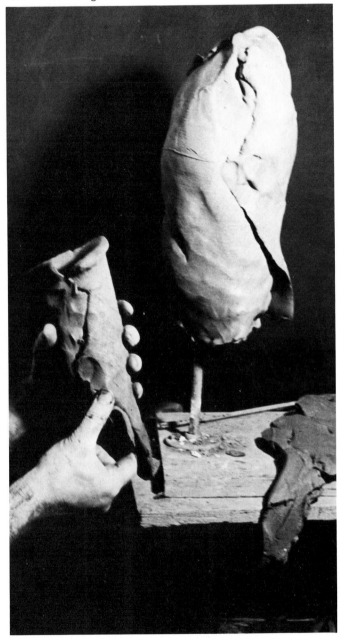

5. He has attached one leg and part of the other by melding the clay of the thighs into the clay of the torso with sharp, smearing, upward strokes of his thumb. Here he indicates the iliac line that separates legs from torso.

6. Lucchesi has pinched in the clay at the top of the torso for the neck and has added a rudimentary head shape. Here he adds slabs of clay for the buttocks.

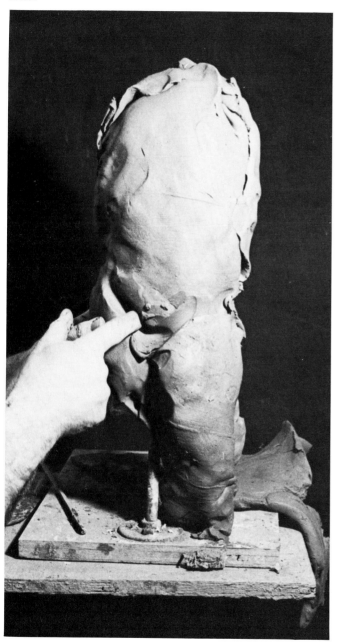

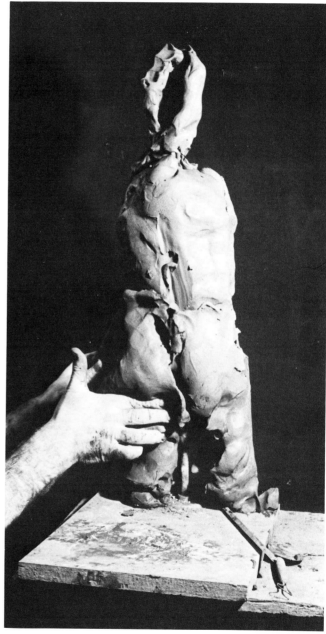

7. Lucchesi has added clay to round out the back of the head and neck and is here working in a slab that he has added to the back.

8. He pulls the clay out at the top of the torso, pushing in with thumbs and the heels of his hands to form the beginnings of the shoulders.

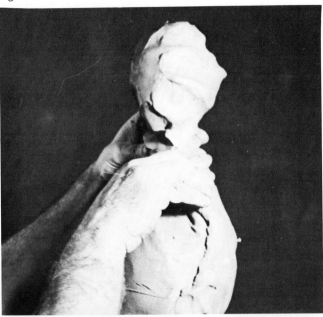

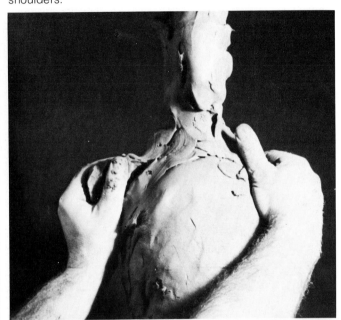

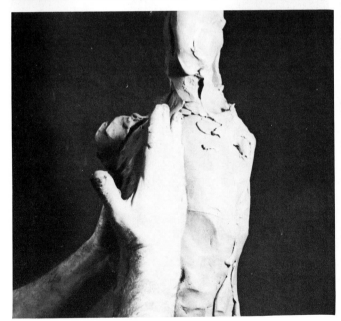

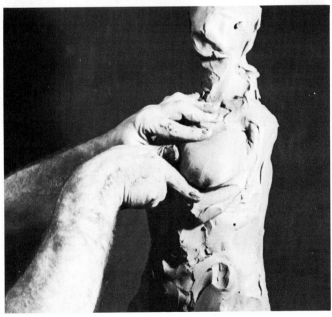

9. Here he strikes the figure with the edge of his hand to form the midline that runs down the front of the body.

10. Lucchesi places a mound of clay on the upper ribcage for the breast, melds it in, and emphasizes the underline.

11. He has placed the second breast and here he adds slabs of clay to form the hips. He shapes and melds them with a sweep of the heel of his hand.

12. He adds clay across the chest, pushing in with his thumbs to form the collarbones.

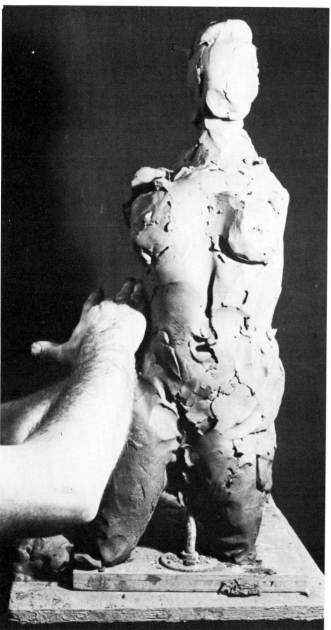

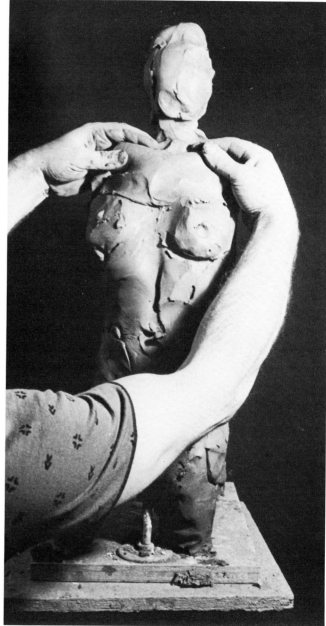

13. Lucchesi now uses a flexible steel palette, which he curves to the contour of the forms as he pulls it over the clay. This serves to blend and smooth the clay as well as give fullness to the rounded forms of the figure.

14. Here Lucchesi cups a breast with the palette and pulls the tool around and up.

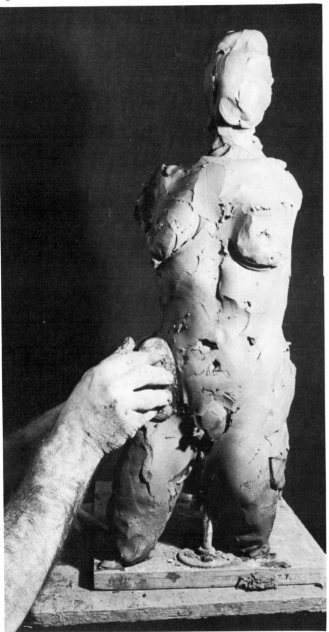

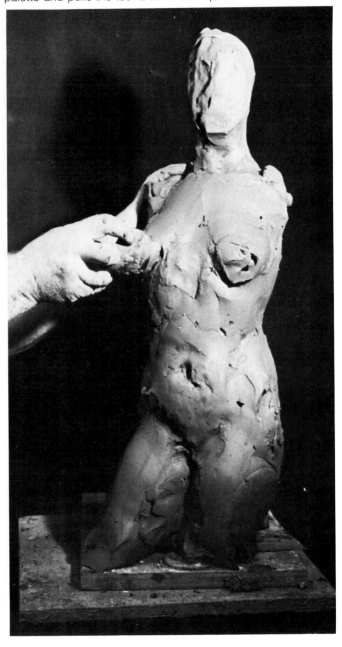

15. At the midline of the body he pulls the palette out from the center and around, in both directions, following the curve of the ribcage.

16. The body also has a midline down the back, along the spinal column. He pulls the palette in, around, and up to define this line and the shape of the back ribcage and muscles.

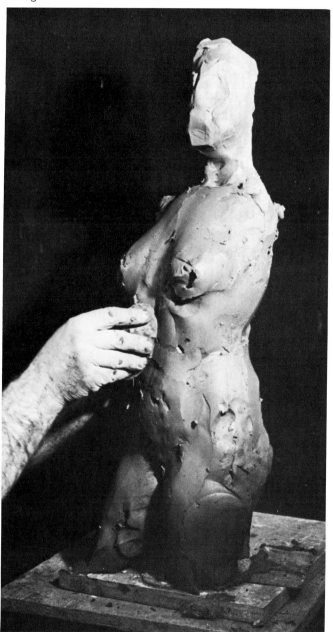

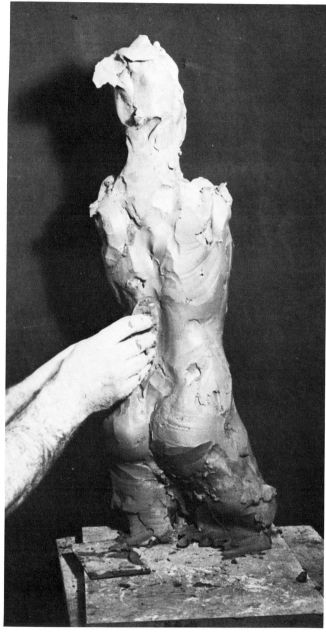

17. More modeling has covered the palette work, and Lucchesi has drawn the V that runs from under the ends of the collarbones to between the breasts as a guide to the proper relationship of forms. Here he adds more clay to flesh out the hips.

18. Lucchesi blends the clay with strokes of his hands and fingers. Here he indicates the dividing line between pelvis and thigh where the leg bends. Notice the palette marks on the hip and over the stomach where he has blended the clay he added in the previous step.

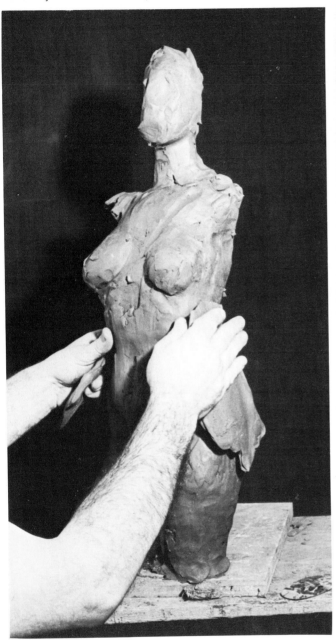

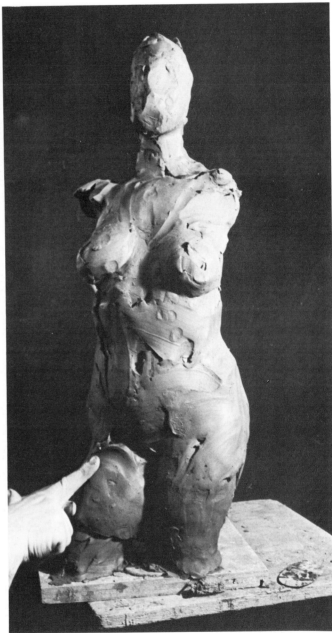

19. More blending and definition. Notice the small fingermarks that follow the round contour of the left thigh. He reemphasises the midline of the body, which was lost, pulling the clay out on either side over the ribcage, and presses in the indentation around the navel.

20. Lucchesi forms the arms as he did the legs, out of a hollow tube of clay made from a flat slab. This arm will be bent, so he bends the tube.

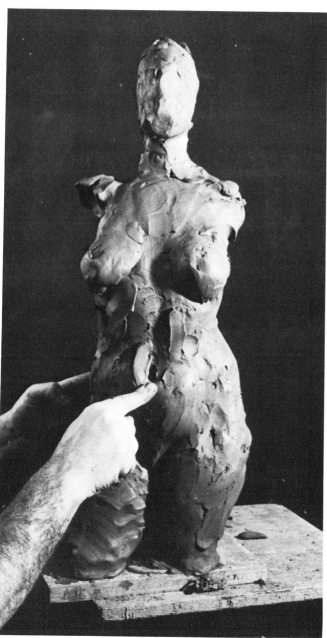

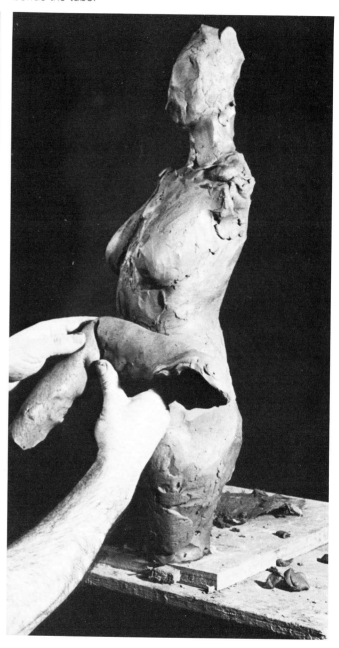

21. He attaches the arm by melding the clay into the shoulder and at the hip where a hand will be resting.

22. The other arm, this one straight, is rolled and put into place. The bent arm at right, because of its angle and because the clay is still quite soft, is temporarily propped up with a modeling tool until it becomes firm enough to stand by itself without sagging. The modeling on this arm was done by curving a flexible steel palette and dragging it around the forms.

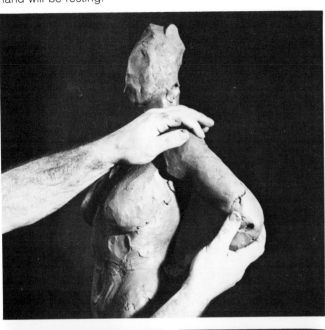

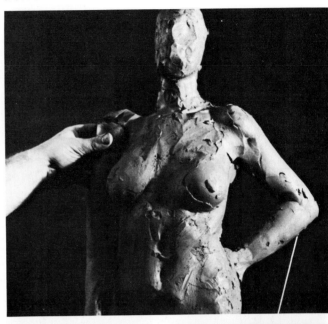

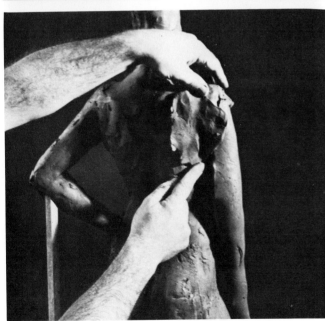

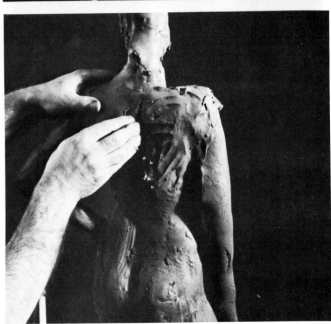

23. At the back, Lucchesi adds clay to flesh out the area between shoulderblade and arm.

24. He blends the new clay into the shoulderblade with short strokes of his fingers.

25. He strikes the back midline of the body, reemphasizing the spinal depression.

26. Lucchesi places a slab of clay over the front of the head, like a mask, to form the face.

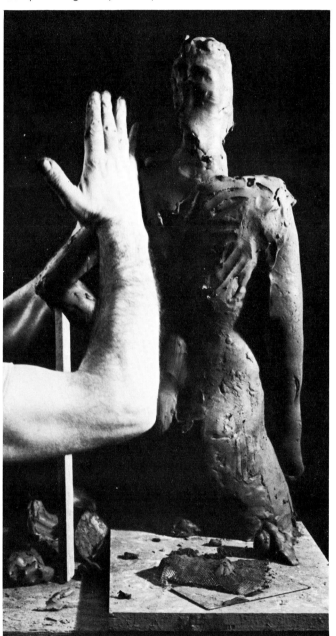

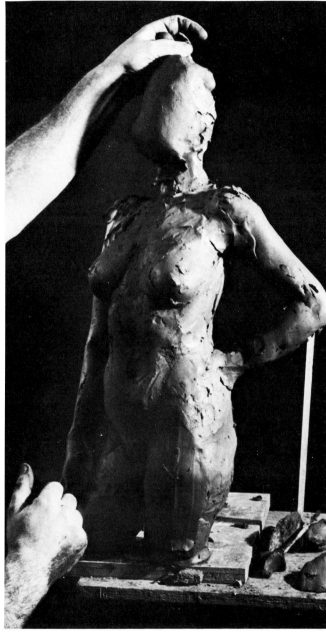

27. Then he draws the divisions of the face with a plaster tool: midline down the center crossed by eyeline, end-of-nose line, and mouth line. He has gouged out the eye sockets and is placing the nose and lips. (For a more detailed description of how to model a face, see Demonstration 5: *Portrait Head*.)

28. Lucchesi adds more clay to the back of the figure; the entire right side of the back is applied in one large slab. In this profile view you can see the work that has been done on the face: the forehead has been built up, the nose defined, and the lips roughed in. Also, he has placed a bit of clay for the ear midway between eye and mouth lines.

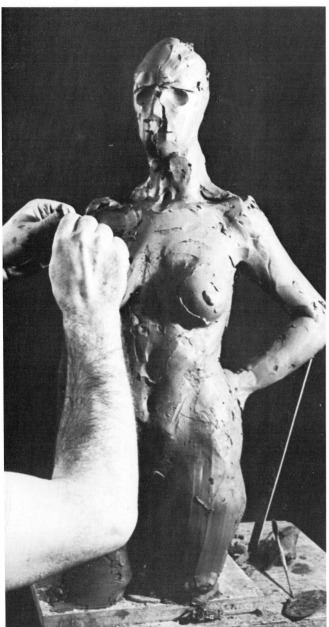

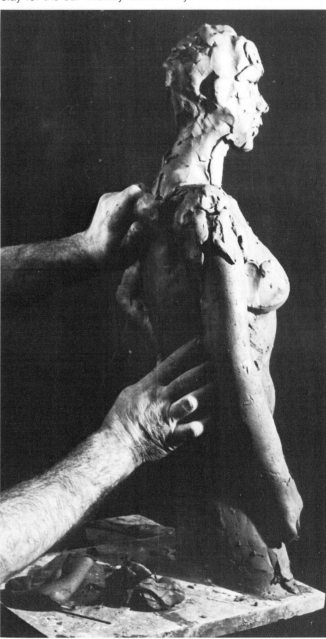

29. After the shape of the skull has been defined and the face has been roughed in Lucchesi adds the hair mass.

30. Lucchesi applies clay for the hand mass first, then he adds the individual fingers, one by one.

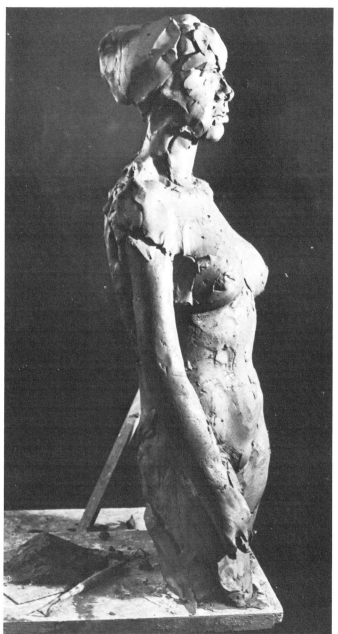

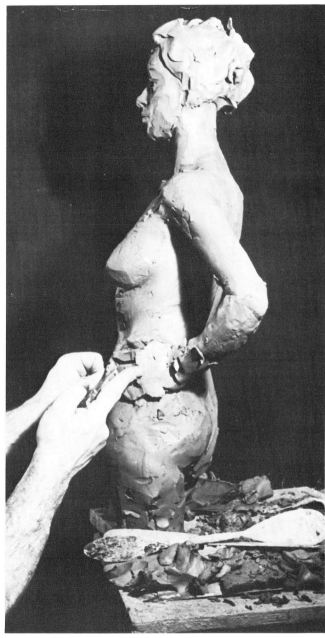

31. He uses a plaster tool to get between the fingers and separate them so that they will have a more graceful placement on the hip.

32. Now Lucchesi takes a piece of coarse-mesh wire screen and pulls it over the surface to get rid of the dips and ridges produced by the handmodeling. A slight pressure exerted while the screen is being moved around and over the forms defines them in large, clear patterns.

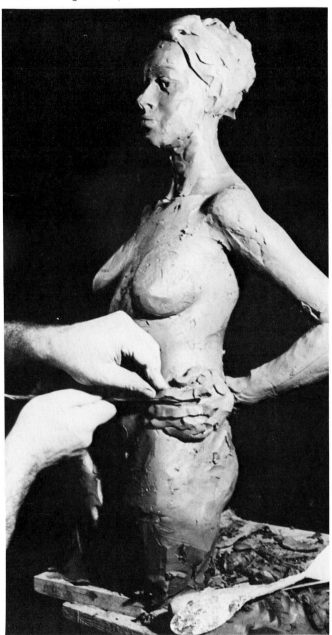

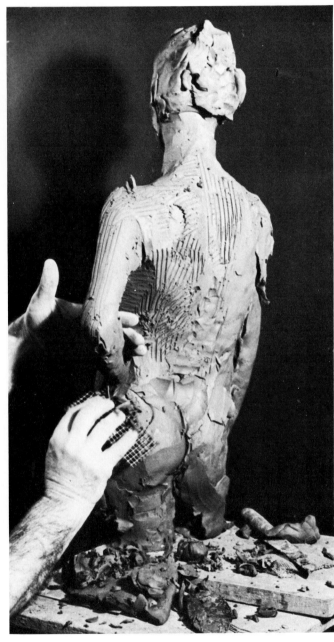

33. Here he uses the screen to blend and shape the shoulder area. Notice the direction of the strokes: out from the spine, across the rounded forms of the back, down the neck to elongate that form, and dipping in to carve out the hollows of the shoulder.

34. The rough texture left by the heavy screen is obliterated by yet finer blending with a finer-mesh screen, dry burlap, and the flexible palette. Here Lucchesi cuts under the buttock with a wire loop tool. He has also carved out the dimples of the lower back.

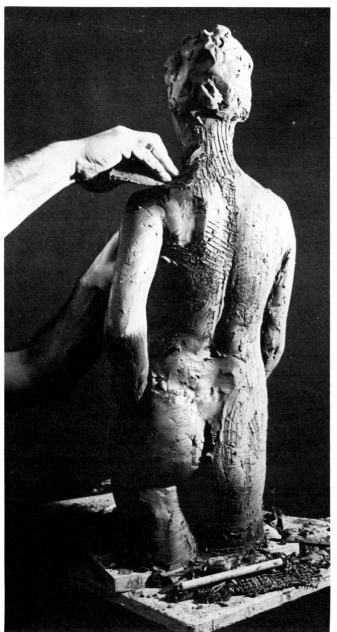

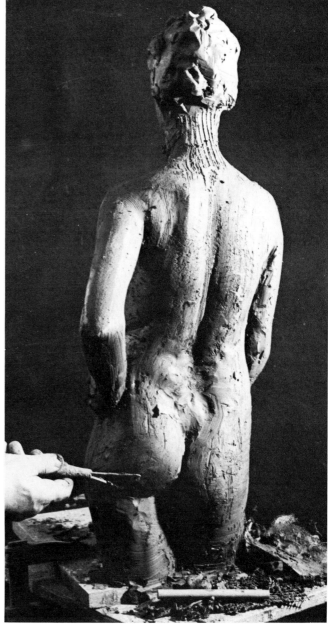

35. Here Lucchesi blends and smooths with a flexible palette. Look at the different directions of these strokes, always following the curvature of the forms. The face has been considerably worked on and the hair has been further defined.

36. Lucchesi rolls coils of clay for the fingers of the left hand and attaches them one by one.

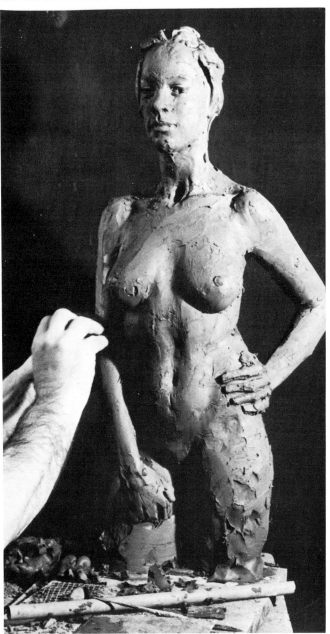

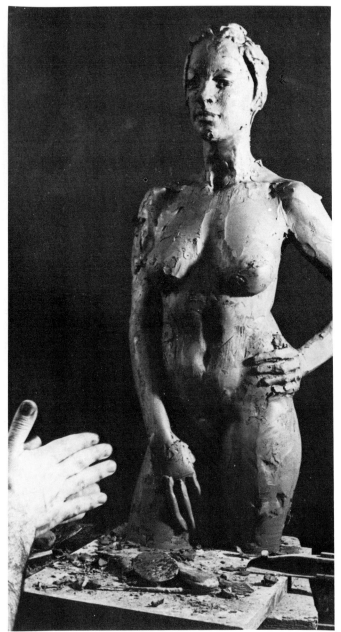

37. Here Lucchesi uses a large housepainter's brush dipped in water to blend and smooth the clay. As always, he follows the direction of the curve of the forms as he draws the brush over the surface.

38. Lucchesi continues to wet-brush the figure, moving around to the back. He cups the arm with his other hand as he brushes to equalize the pressure exerted by the brushing movement. The brush is drawn around, not straight up and down, the arm.

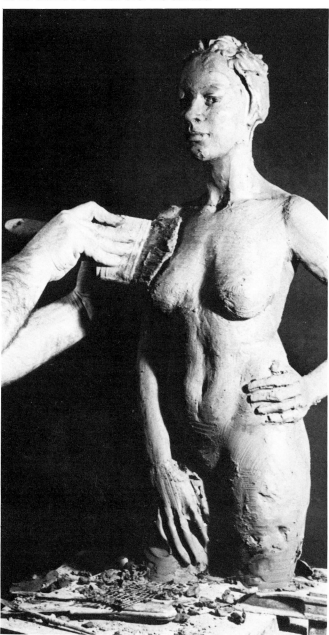

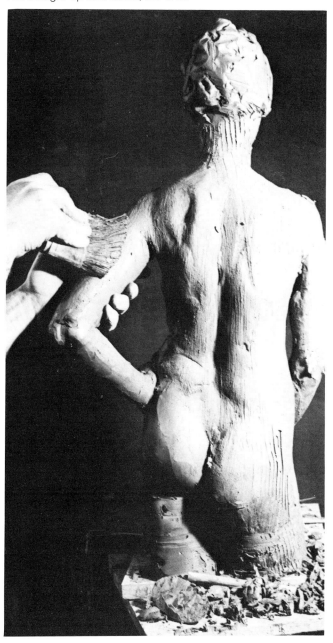

39. More shaping, this time with a hacksaw blade which Lucchesi draws over the surface, gently shaving away excess clay.

40. This texturing technique enables Lucchesi to see the forms beneath in larger planes, which helps him emphasize the overall movement of the piece and get rid of distracting and unnecessary details. The tool is simply a piece of burlap cut from a burlap bag. Lucchesi wets the burlap, slaps it onto the surface, and with his hands moving over it, molds the forms beneath.

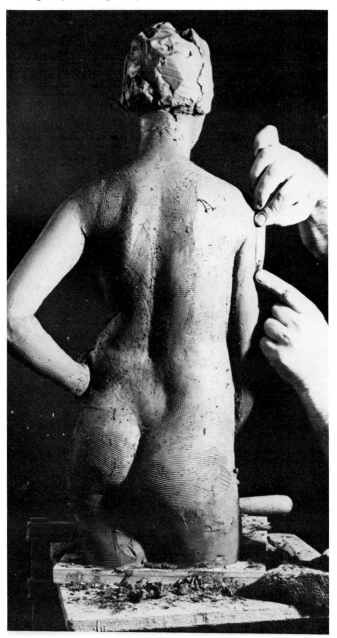

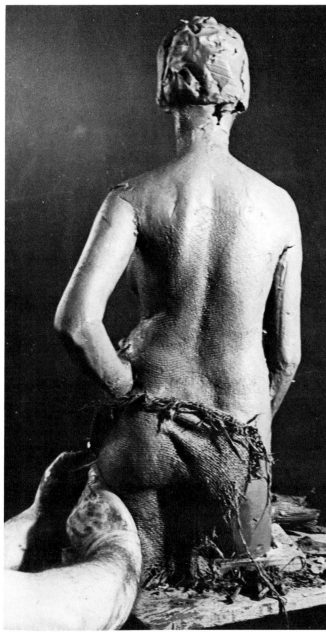

41. More texturing and blending with wet burlap. Lucchesi presses the material firmly into the dips and crevices of the figure as well as working it over the surface.

42. After allowing the clay to firm up a bit, Lucchesi further refines the surface with a piece of dry burlap, used in the same way that you'd use sandpaper, to smooth and blend.

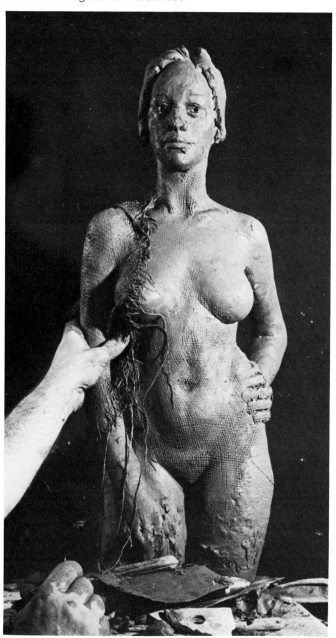

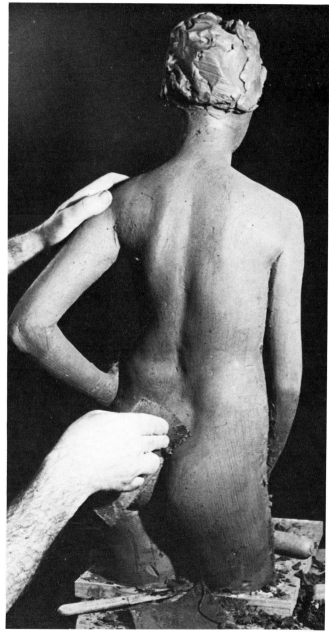

43. To show the movement and pattern of the hair, Lucchesi draws a piece of coarse screen in the direction he wants the hair to fall.

44. Here Lucchesi uses a wire loop tool to carve the lips. He has also used it to carve out the nostril, the line of the eyelid, and the underside of the eyebrow.

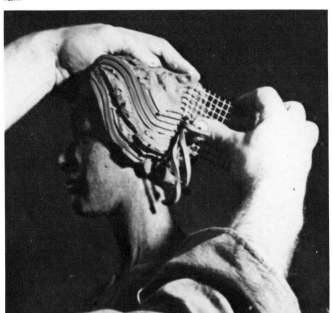

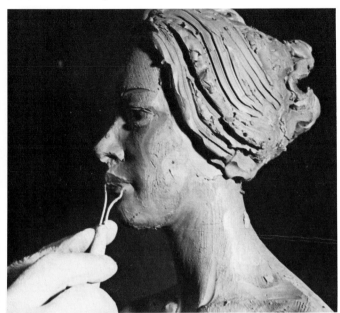

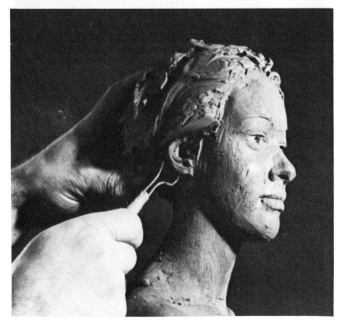

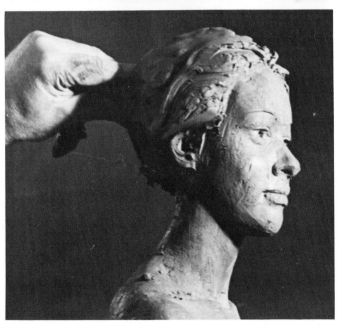

45. He roughly draws in the basic S shape of the ear with a wire loop tool and cuts away some of the clay behind the ear so that it will protrude properly.

46. Lucchesi now arranges the hair, experimenting with hairstyles and pulling it up to see how it will look.

47. With a wire loop tool he emphasizes the hair patterns.

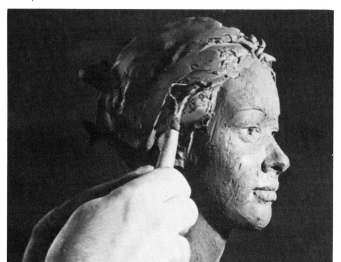

49. A few deft pats with the flat side of a pick-ax head emphasize the flat planes in the hair pattern.

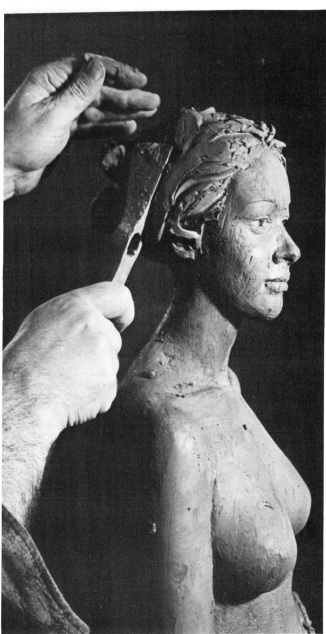

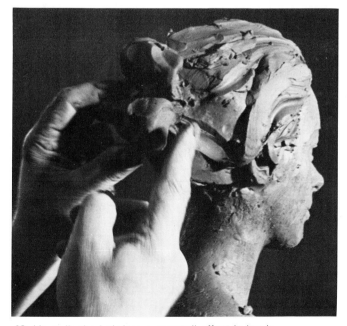

48. He pulls the hair into a ponytail effect in back.

50. This closeup of the hand shows how Lucchesi puts on the fingernails; they are simply carved across the ends of the fingers with a stroke of a wire loop tool or plaster tool. The stroke is firm and even, pressed down slightly harder at the starting and ending points, which gives the indented side edges to the nails. The tool is then drawn across the tips of each finger to indicate the end of the nail.

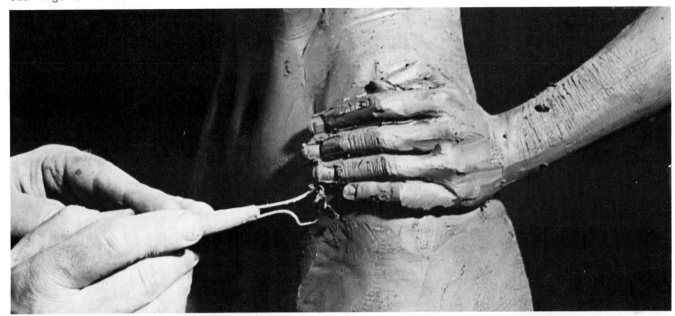

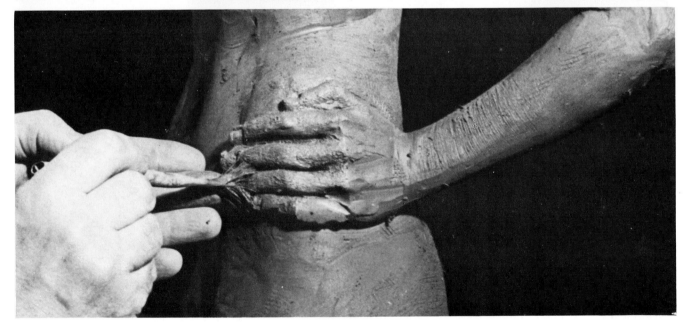

51. Here Lucchesi blends the newly carved forms of the hand with a small brush dipped in water.

52. Lucchesi goes over the entire surface with a very wet paintbrush, swirling the bristles around the forms. Notice how the nipple is accentuated: a circle is roughly drawn around a small raised center, a contrast that gives it "color."

53. The clay is dryer now, and you can see the beginning of the fine-grained, uniform texture of the finished piece.

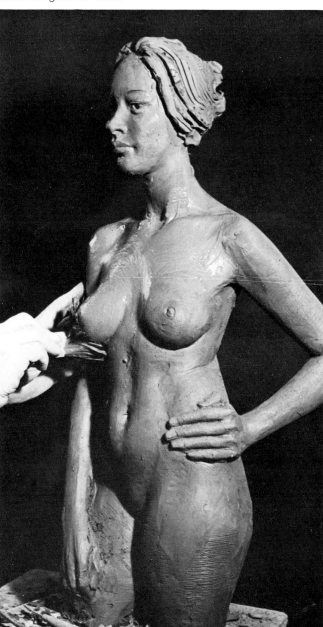

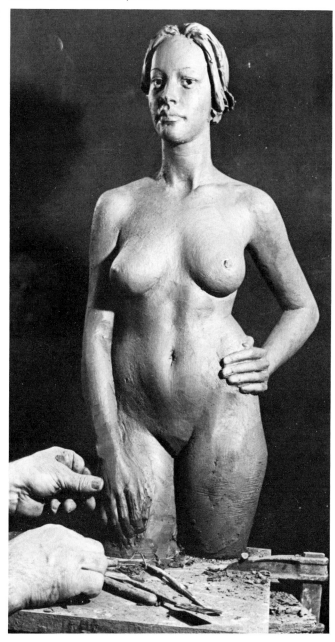

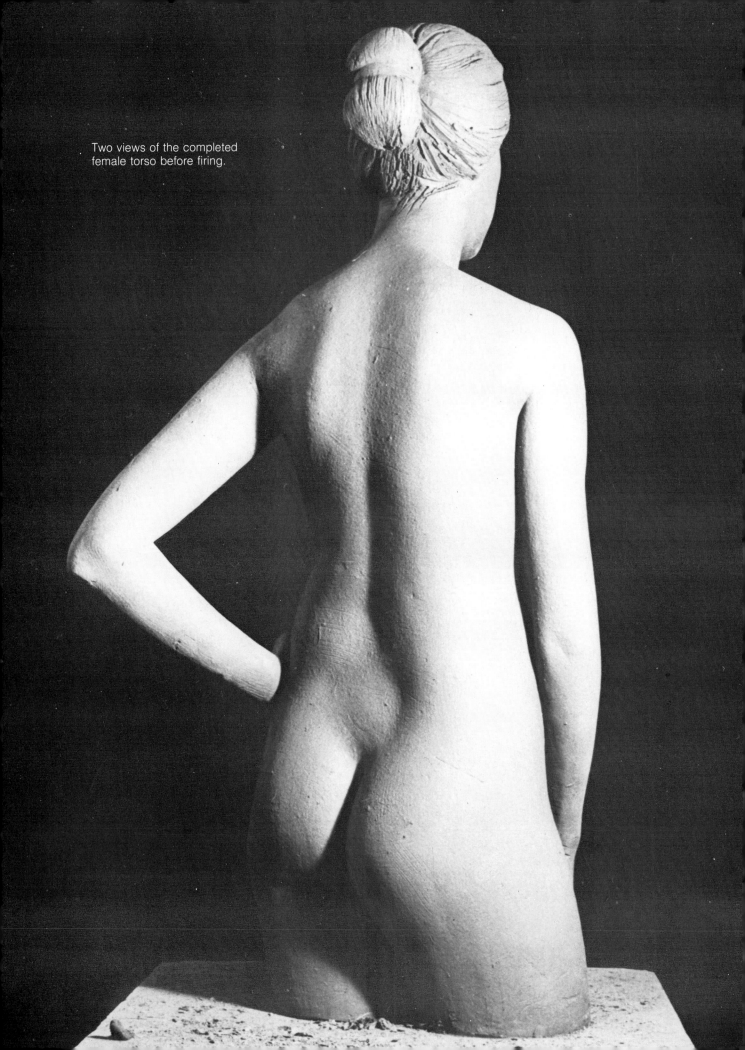

Two views of the completed female torso before firing.

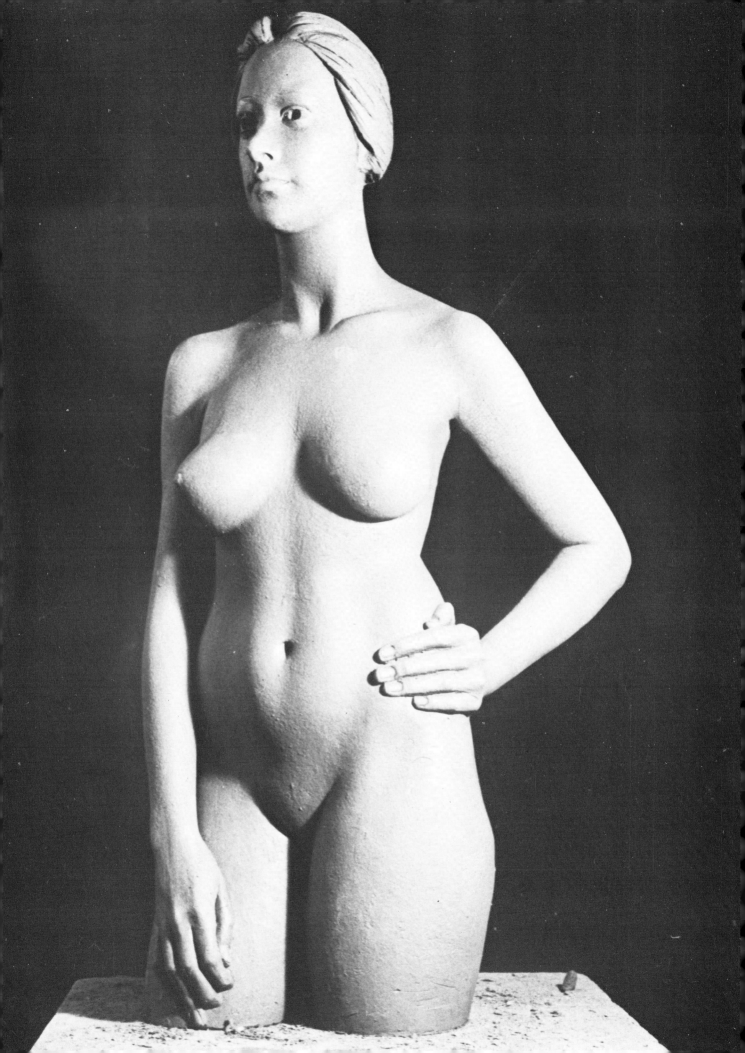

DEMONSTRATION SEVEN
MALE TORSO

The male torso is built around a paper core in the same way and on the same armature as the female torso in the preceding demonstration. It is removed from the armature and pierced in the same way, too.

The major difference between this demonstration and the female torso is of course the difference in the surface anatomy. The muscle structure of the male is more pronounced, enabling you to see the anatomical details more clearly than on the female. This demonstration is not intended as a lesson in anatomy, although we'll have to use some anatomical terms to describe what's happening. Rather, it's intended to show you how the anatomy of the human body can be handled in an uncomplicated way. In other words, we'll try to take the fear out of tackling anatomy. You'll notice that Lucchesi doesn't build up the figure by adding small bits of clay so much as by whacking on great slabs or twisting a coil in the shape of a muscle and laying it on. His first rough-in of any given muscle group is usually a single piece of clay shaped more or less like the muscle or muscles it is intended to be, and placed in position. In this way, the form is basically correct from the beginning. This is a very important concept: place the forms of the body—from individual fingers to shoulderblade—correctly at the very start. This will save hours of correcting and patching up later and give the piece a uniform appearance and correct proportions. This is a very different approach from the way one is taught to model in art school, so it may take some getting used to. It's a kind of shortcut that works best if you are already somewhat familiar with anatomy. If you're a beginner you might find it more comfortable to build the muscles up bit by bit, slowly and carefully. But Lucchesi's technique greatly simplifies not only individual forms themselves but the modeling process as well. It's certainly much faster, and it lends itself to a greater freedom and spontaneity in modeling, enabling the sculptor to see the whole piece as it evolves instead of getting bogged down in building up separate sections.

1. As in the previous demonstration, Lucchesi wraps newspaper around his armature and covers it with a bag. Now he applies a flat slab of clay over the paper, closing it around the bottom. He adds a similar slab to the other side and works the edges together, covering the entire form.

2. Lucchesi has attached one leg and is forming the other by rolling a slab of clay into a tapered tube shape.

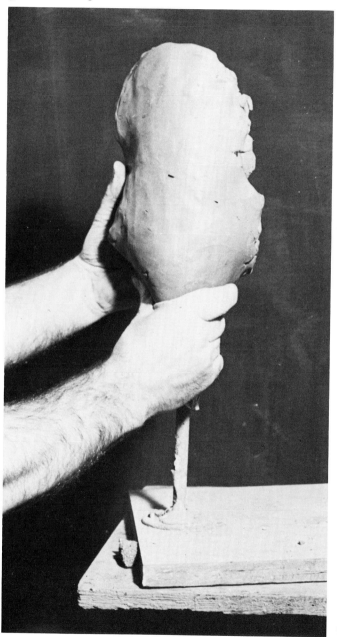

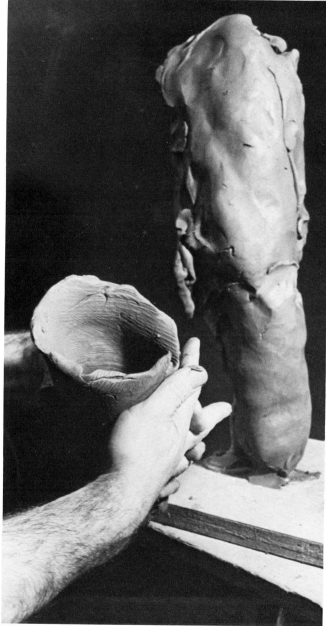

3. The arms are also hollow tubes of clay and are attached as the legs were, by working the clay into the body with smearing, pushing movements of the thumb.

4. Lucchesi has added a rudimentary head mass. Now he slaps a slab of clay onto the back and buttock area.

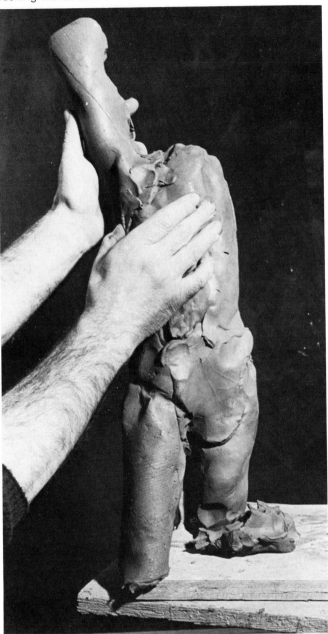

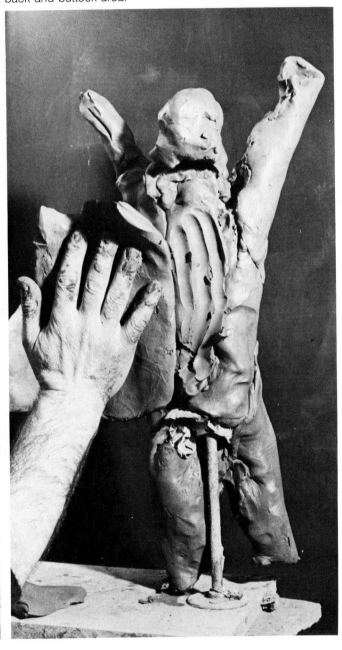

5. He strikes the newly added clay with the side of his hand to form the midline division of the body along the spinal column.

6. He forms the buttocks with a flexible steel palette. He slightly bends the palette so that it moves around the buttock form as he draws the tool downward.

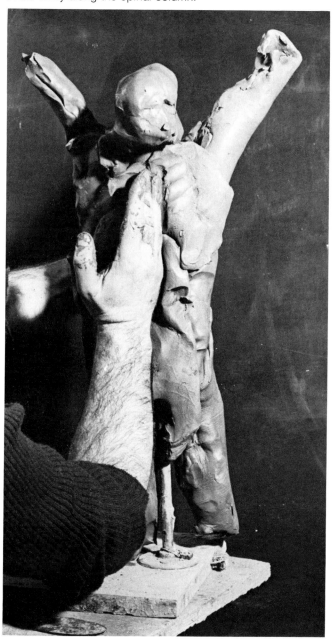

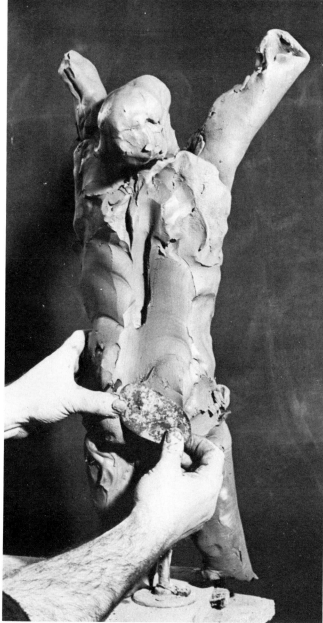

7. With his forefinger, Lucchesi draws in the major divisions of the back: the spine, the shoulderblades, the buttocks, and the indentation between the iliac crest and the back muscles.

8. Moving around to the front, Lucchesi draws the clay together with sweeps of his fingers, held firmly together, from top to bottom and from side to side over the surface.

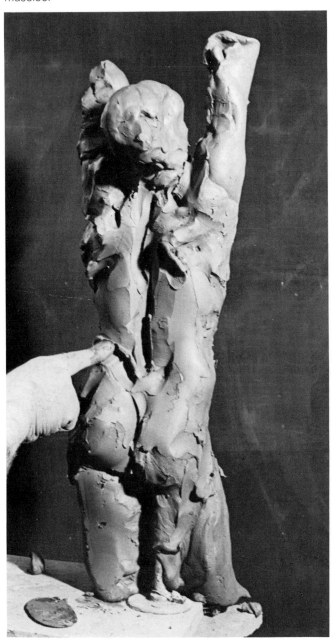

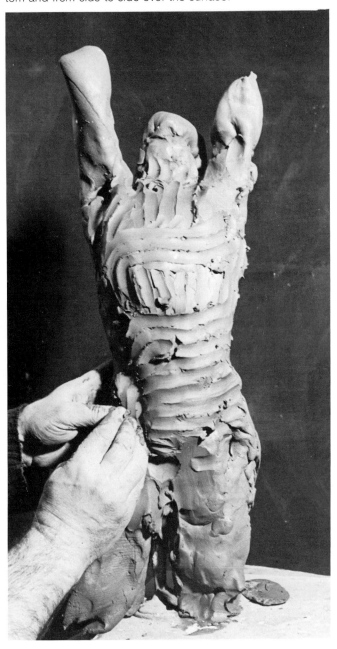

9. He slaps a slab of clay over the hip area to add fullness there.

10. The surface has been further modeled and blended. Here Lucchesi draws the midline of the front of the body and the breastline with a wire loop tool.

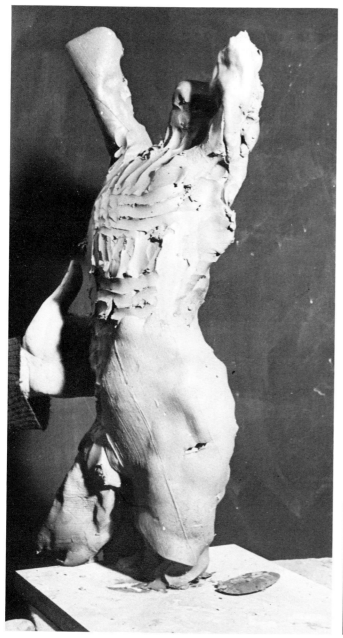

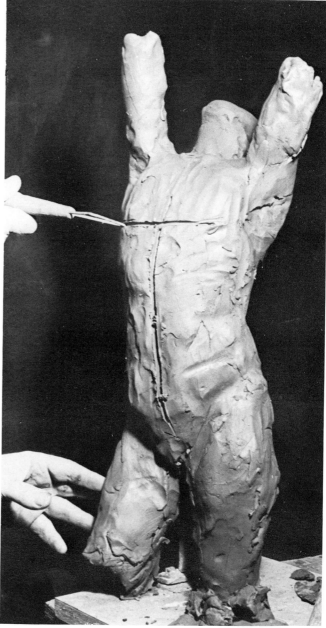

11. He has now drawn in the major crosslines of the abdomen, as well as the arching vault of the ribcage. Notice that because the torso is standing with one hip thrust out the crosslines are drawn at an angle to each other. Here Lucchesi adds the left pectoral muscle.

12. Aided by his drawn guidelines, Lucchesi has added the right pectoral and is now adding clay to the upper ribcage.

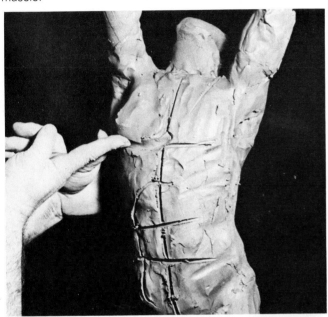

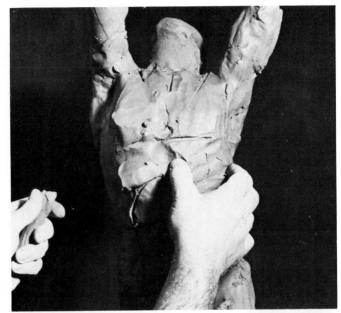

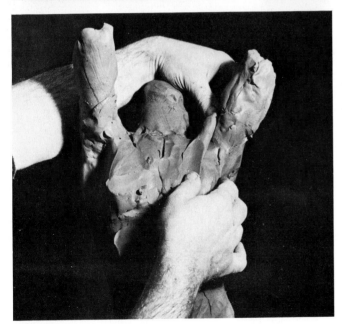

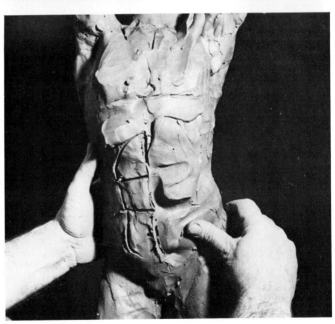

13. He runs the top part of the pectoral, which is being pulled up by the upraised arm, over the shoulder.

14. He applies clay inside his guidelines and models the bulges of the rectus abdominis muscle.

15. Again following his guidelines, he has accentuated the ribcage arch over and around the abdominal bulges and has extended the indentation down under the belly to indicate the iliac line. Here he roughs in the genitals.

16. With firm chops of his fingers Lucchesi indicates the "fingers" of the serratus muscle as they interweave with the external oblique muscle that covers the side of the body.

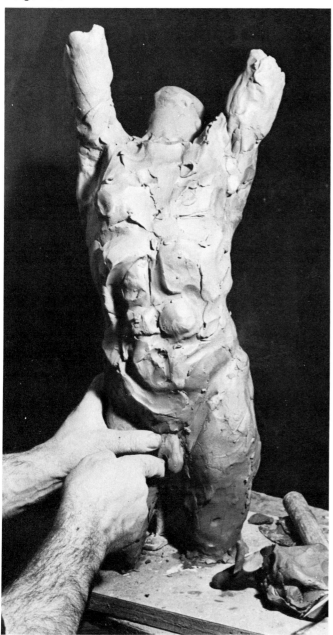

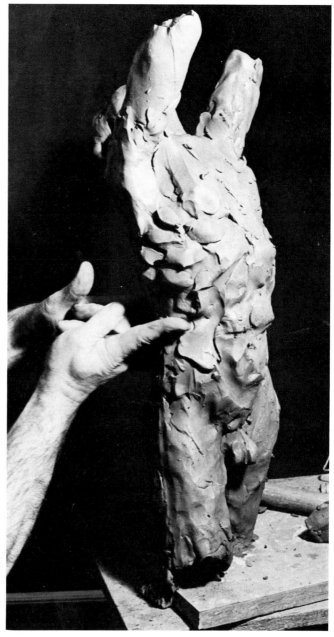

17. He adds clay to the back and with the side of his hand pounds it to form the ridges and hollows of the shoulderblade.

18. He draws the iliac line between groin and belly.

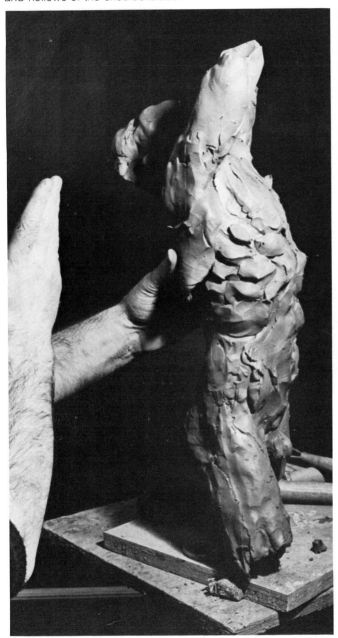

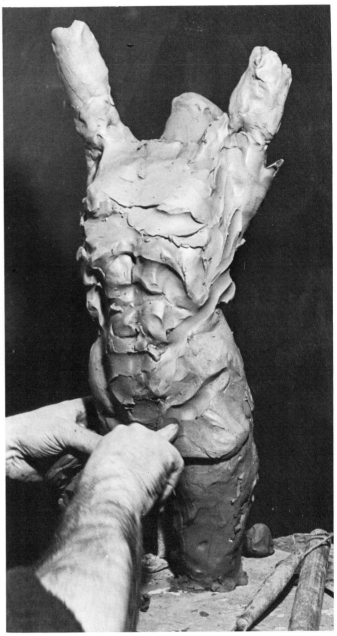

19. Lucchesi smooths the surface with swipes of his thumbs and with a flexible palette. He has blended the forms of thighs and groin, the abdominal bulges, and ribcage arch, and the pectoral muscles so that they truly seem covered by a layer of skin.

20. Lucchesi curves the flexible palette and draws it over and around the forms, here defining the full, round form of the buttock.

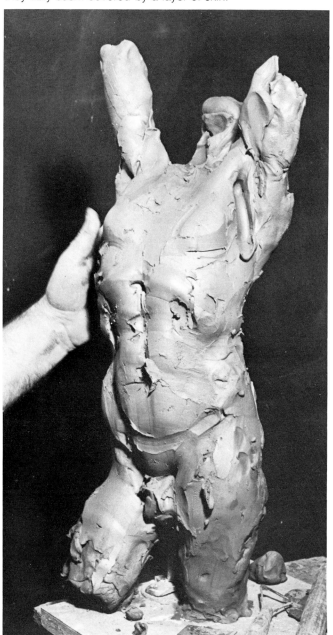

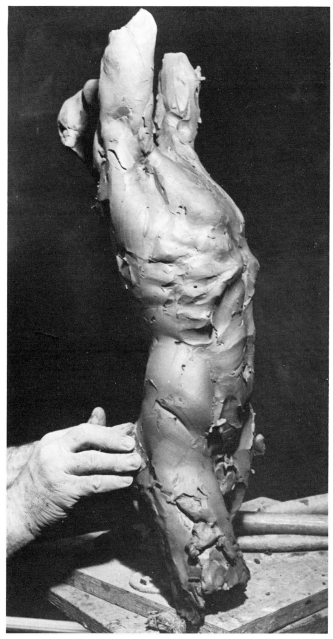

21. This view from the back shows more blending and smoothing with the palette.

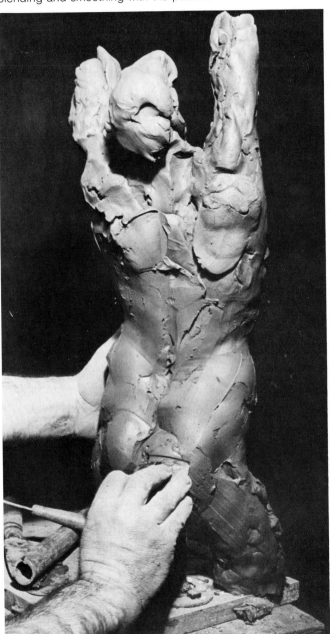

22. Now Lucchesi goes over the entire figure with a large housepainter's brush dipped in water. He draws the brush around the forms, modeling and blending them as he goes.

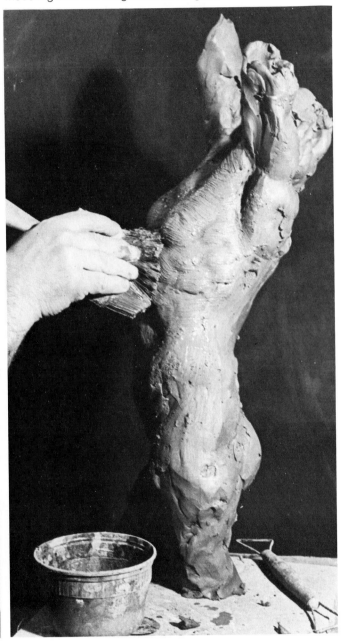

23. Lucchesi also uses the brush dry, full of the powdered clay that has dried in the bristles. The dry brush may be drawn over the surface just as when it's wet, but of course it produces a different effect. Also, it may be brushed in quick back-and-forth strokes over the surface. Here he uses the end of the brush to indent the navel.

24. Lucchesi redefines the genitals, adding clay for the penis.

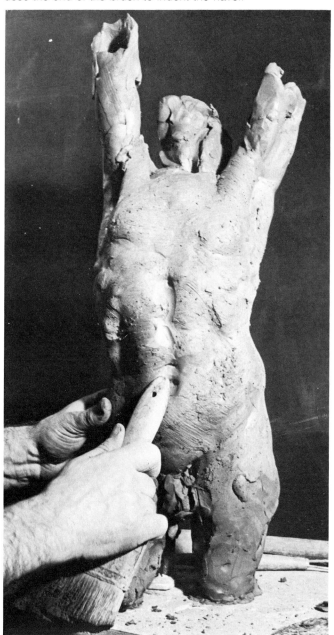

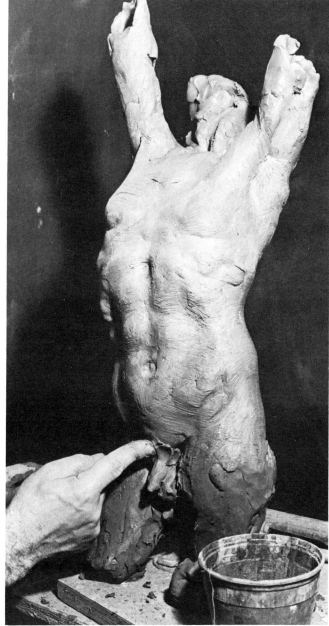

25. He decides to add a forearm to the arm at left. This, like the upper arms and thighs, is a hollow tube.

26. He has worked the forearm into the upper arm with thumbstrokes at the elbow. He has also added to the arm at right so that it goes all the way to the elbow. Now he draws a wire loop tool around the muscles. He brings it down the arm on the inside line of the biceps, intersecting with a line between the outside line of the biceps and the bulge of the muscles over the shoulderblade, and along the outline of the pectoral muscle.

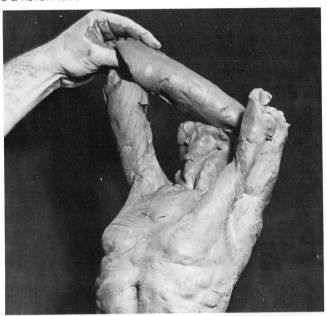

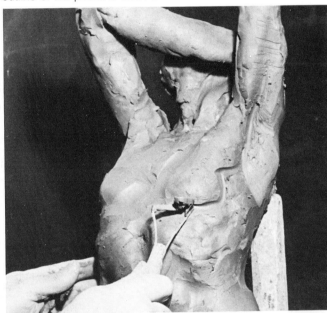

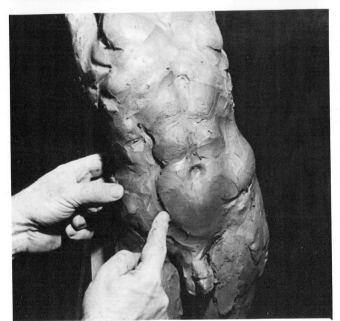

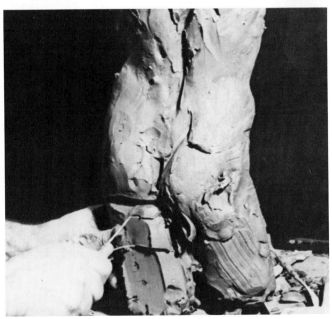

27. More redefining: here the indentation between the side of the body, the external oblique muscle, and the abdomen (the rectus abdominis). He runs this line down into the lower part of the iliac line that divides the belly from the groin.

28. Now, moving around to the back, Lucchesi removes large chunks of clay from the thighs with a wire loop tool. He has added more clay to the back of the head to form the skull mass and the hair.

29. He smacks the buttocks into shape with the flat of a trowel. This whacking technique is very good for forming large planes in the surface.

30. He carves out the hollow between buttock and hipbone with a wire loop tool.

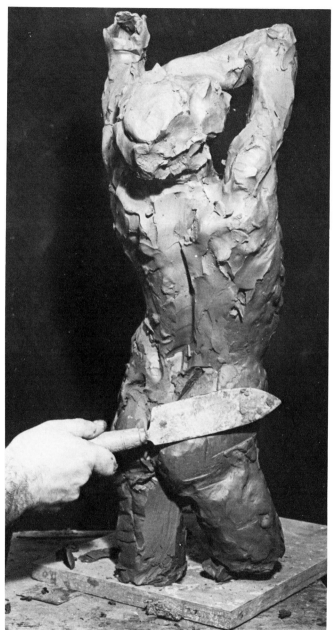

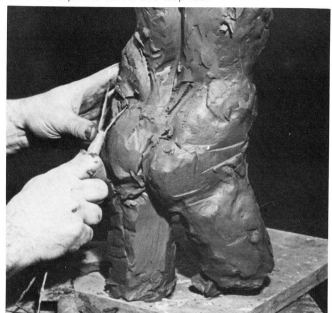

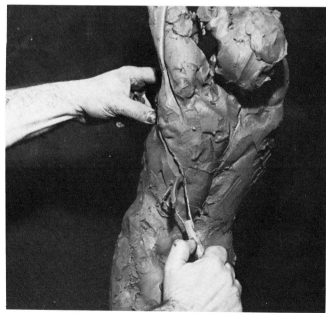

31. Here he runs guidelines down the body to indicate the major muscle patterns of the side when the arm is raised: the deltoid muscle coming down over the shoulder, and the large side muscle, the latissimus dorsi, going up and around the small bulge, the teres major, just below the arm.

32. More muscle definition. Starting at the elbow and working down, you can see the triceps, the bulge of the deltoid going into the depression between shoulder and shoulderblade, the furrows down the side of the body caused by the pulling up of the teres major and the latissimus dorsi, and the serratus muscle "fingering" into the external oblique over the ribcage. Now, using a wire loop tool, Lucchesi carves the depression formed between the protruberances of the hipbone and the top of the leg.

33. He scrapes outward from the spine with a flexible palette to form the two halves of the back. Here you can see the basic shape of the buttocks as they flow out of the hipbone and as they relate to the lower back area.

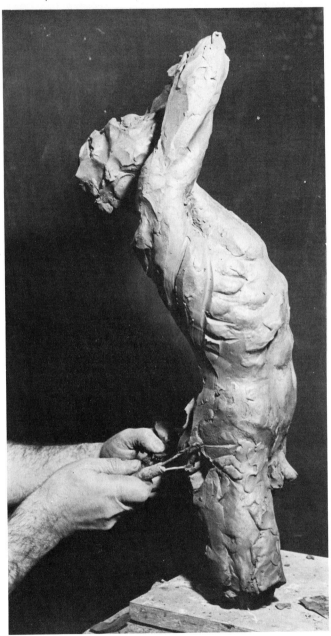

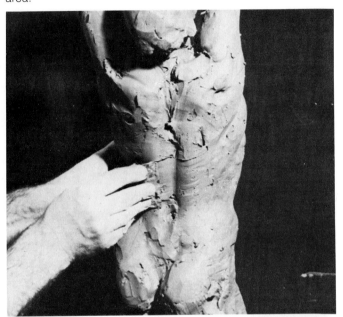

34. Lucchesi puts the fingers on the hand one by one. He holds a hand behind the fingers as he works to equalize the pressure exerted by his thumb.

35. Here he draws a piece of coarse wire screen over the body, swirling it around the forms to shape them and digging it in to remove clay.

36. A few well-placed whacks with a stick help Lucchesi further define the shape of the buttocks.

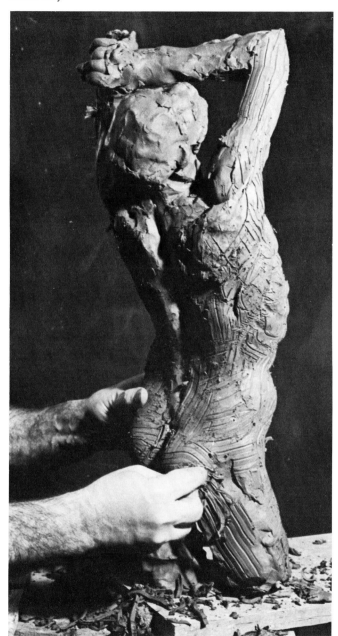

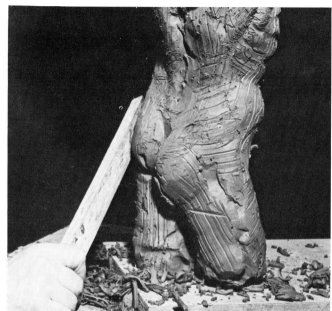

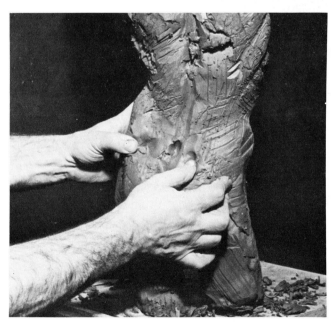

37. Digging in with his thumbs, Lucchesi indicates the dimples in the lower back, over the buttocks.

38. Now, using a wet housepainter's brush, he blends and smooths the clay, swirling the brush in the direction of the forms.

39. Moving around to the back, he further defines the roundness of the buttocks with a flexible scraper.

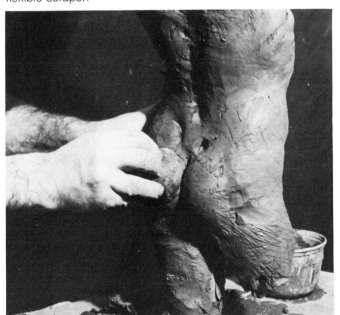

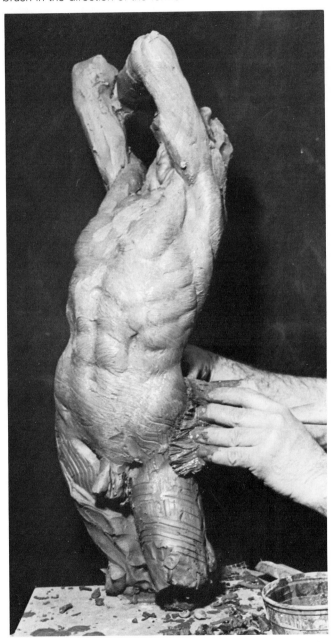

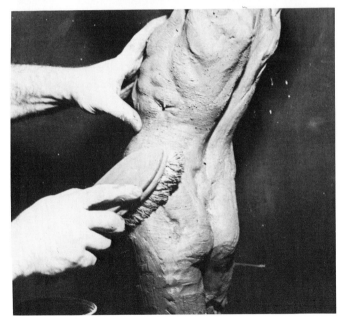

40. Lucchesi uses a dry scrub brush to further blend the surface.

41. To reemphasize the indentations and hollows of the back, Lucchesi digs into the clay with a piece of coarse screen, always moving in the direction of the forms.

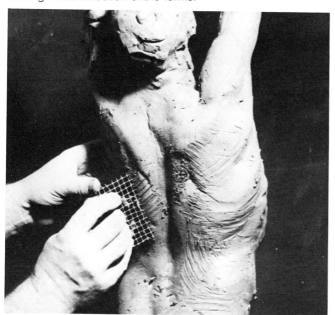

42. Going from a coarse screen to a finer mesh, Lucchesi draws a bit of dry burlap over the surface.

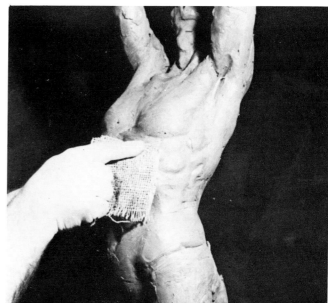

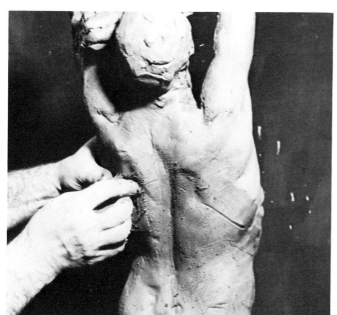

43. Now he works a fine-mesh screen into the hollows and across the surface to further refine the modeling.

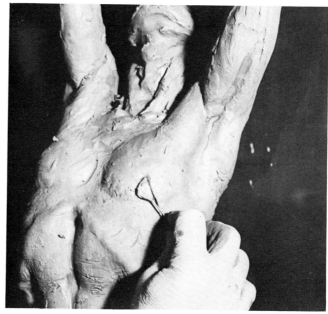

44. Lucchesi places the nipple with a deft flick of a wire loop tool. Notice the strong V of the sternomastoid muscles of the neck and the arc of the jawbone.

45. Still using the wire loop tool, he reemphasises the iliac line between belly and groin going up to below the iliac crest, or hipbone.

46. Here he smooths the surface with a piece of sandpaper moved over wet cloth.

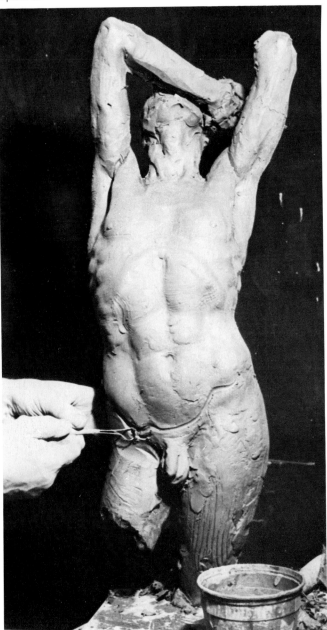

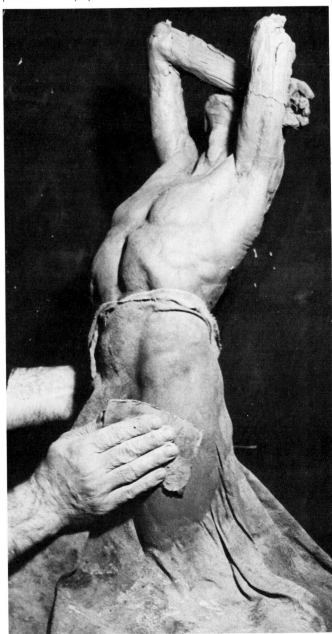

47. Lucchesi now does some fine modeling with a wire loop tool, picking up details that were "lost" in the smoothing operations. He's decided that the figure will have a better balance compositionally if the right arm were to end not at the elbow but lower down. So he has snapped off the offending portion.

48. Lucchesi whacks a little more indentation below the ribcage with a length of pipe.

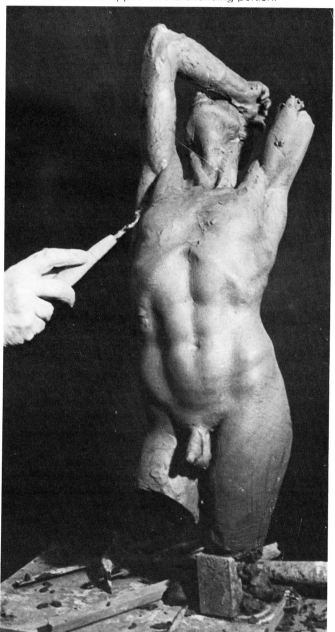

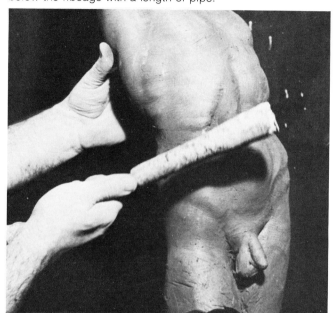

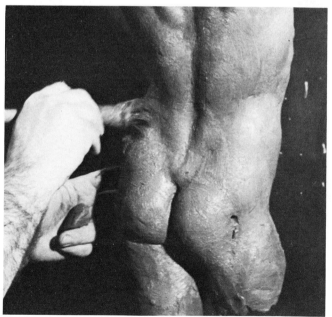

49. He swirls a small wet brush over the entire surface to blend and smooth the clay. This blending with a fine wet brush provides the final texture of the piece.

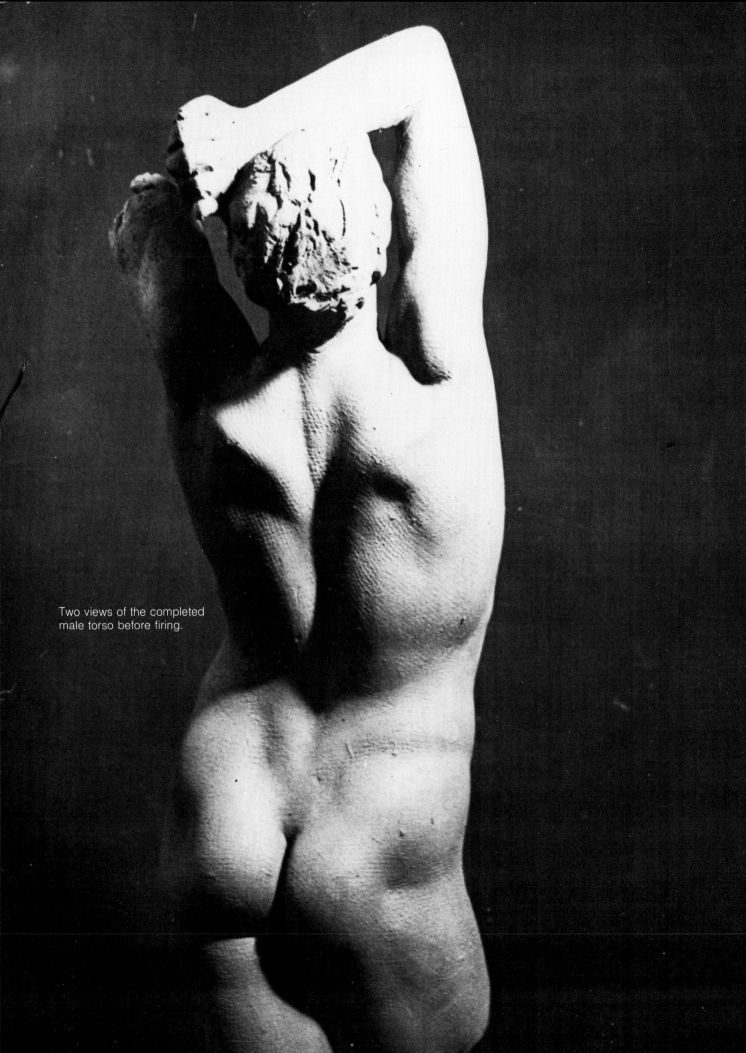

Two views of the completed
male torso before firing.

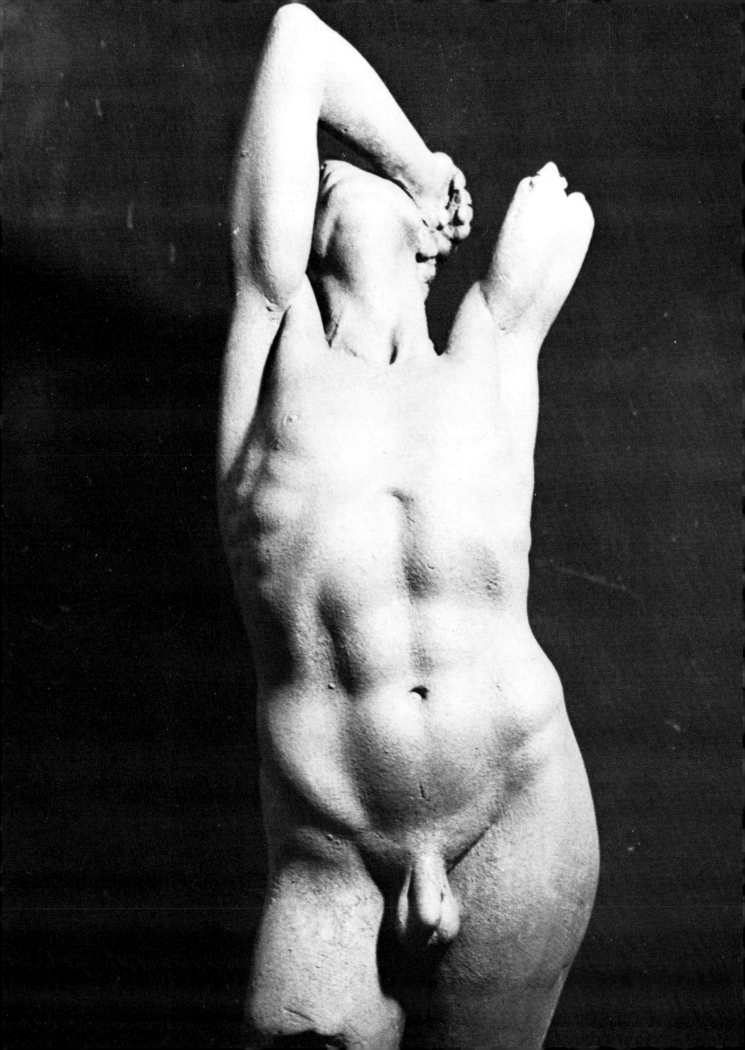

FIRING AND FINISHING

Once your sculpture is completed and removed from its armature, it may be allowed to dry out in preparation for firing and finishing.

DRYING

If you attempt to fire clay that still retains moisture you run the risk of breaking the piece. It must be allowed to dry out thoroughly before it is placed in the kiln. Until you get the feel of the material you may want to control the drying so that the clay loses moisture slowly and evenly. If the clay dries too fast or if it is force-dried, by a radiator, for example, it can develop a bone-dry outer skin that will lock moisture into the interior of the piece. To dry a piece slowly, keep it covered for a week or two with a plastic sheet, opening the plastic up bit by bit until you remove it altogether. If any part of the piece starts to crack due to the natural shrinkage of the clay that accompanies drying—for example, an arm that's attached both at the shoulder and the hip —simply brush water onto that part until the clay swells back to its wet fullness, then wrap the area in plastic to keep it moist while the rest of the piece dries. Once the clay has stopped contracting, unwrap the "bandaged" area and let it dry, too.

The length of time each piece requires to become bone-dry depends on the thickness of the clay wall. A very thin relief may take a few days, a full figure a couple of weeks. If in doubt, it's better to let the piece dry longer than to put it into the kiln prematurely and risk breaking it. As the clay dries it changes color from rich terracotta to a dusty pale shade. Also it becomes porous, losing the plump, smooth texture that it has when the clay is filled with water.

As soon as your piece is bone dry it can be fired. Kilns operate most efficiently and economically when they have a full load, so you may want to wait until you have several pieces before firing. If you don't have your own kiln and must transport your sculpture to be fired outside, keep in mind that the material is most fragile in this state: the slightest pressure at a weak point can snap off part of the sculpture. So wrap it securely in towels or packing material and place it in a box. Wrap it up as if you were going to send it by mail, with plenty of protection against shock; don't carry it in a paper bag. If breakage occurs at this point, fire the broken pieces and glue them back together with epoxy after firing (see the section "Repairing Breaks" in this chapter).

LOADING THE KILN

Place your sculpture in the kiln very carefully; this is where the most breakage occurs. Pieces may be placed lying on their sides, propped against the kiln wall or on short kiln posts, or upright. If you prop a piece against the kiln wall, don't lean it directly against an element (the electrical coil that heats the kiln). Don't lean pieces on one another. You'll have to experiment to see which position is most secure for each piece.

FIRING TEMPERATURE

The higher the temperature the greater the shrinkage but the stronger the clay body. Also, at higher temperatures the clay becomes darker and takes on more interesting surface characteristics. You'll have to experiment with different firings at different temperatures to see what pleases you. But to begin with you should fire relatively low and bring the temperature up very slowly to minimize the risk of breaking your piece. Lucchesi fires his work at cone 06. The firing range of the clay he uses is cone 06–2, which means it can be fired at any temperature within this range. (You'll find the firing range of your clay printed on the label of the container it comes in.) Cone 06 is a low-temperature bisque firing, about 1830° F. (999° C.), that produces a light-colored, porous body.

FIRING SCHEDULE

You'll no doubt develop your own firing schedule. Firing is a bit like cooking: no two people do it exactly the same even when they're following the same recipe. But until you've had the chance to experiment with different tempera-

tures and variations in how long you leave the kiln on Low, Medium, and High, you might want to follow Lucchesi's 8-hour schedule, broken down as follows:

Low, with lid propped open	5 hours
Medium, with lid propped open	1 hour
High, with lid closed	2 hours

After shutoff the kiln takes 8 hours to cool off—a process which must be allowed to proceed naturally, with the kiln lid kept shut. The fired ware should not be removed from the kiln until you can touch it with your bare hands.

Caution: If you are in the vicinity of your kiln while it's firing, make sure there's adequate ventilation. The fumes given off during firing contain impurities from the clay as well as from the burning newspaper.

REPAIRING BREAKS

Unfortunately terracotta is breakable, so it's sometimes necessary to repair it. Even if a piece breaks in the kiln—and an air bubble in the clay can blow a piece into a lot of fragments—it can be repaired. First, gather up all the fragments. Lay these out on your worktable and reconstruct the piece so that you know exactly where and how each fragment fits. Don't glue anything until you go through this dry run. Now mix some 5-minute epoxy (unless you don't want it to dry as fast or you need a really indestructible bond, in which case use 24-hour epoxy). Working carefully so you don't get any epoxy on the surface of your sculpture or on your hands, glue the fragments together. Any glue that oozes from the seam should be removed when it's tacky, not when it's wet, as it will just smear around and make an even bigger mess. But don't leave it until it's completely hard, because by then it's made a bond with the porous clay and is difficult to remove without actually scraping off a layer of clay. Don't mix more glue than you can use in 5 minutes and never rush in order to use the glue you've mixed before it sets; let it go, and mix some more.

PATCHING AND RECONSTRUCTION

Once your piece is glued together the seam may be so small as to be unnoticeable after you've patined the sculpture. On the other hand, it may be very noticeable. Whole sections may be so damaged they need to be reconstructed. All patching and reconstructing must be done before any kind of finish is applied to the fired clay. Mix water putty (available in powder form from hardware stores) with water according to directions until you have a thick paste. This material hardens in minutes, so don't mix more than you can conveniently use. Water putty dries to a light cream color, much lighter than terracotta, so in order to match the color you'll have to add a coloring agent to the putty. Any water-soluble color will do, even fabric dye. Remember when trying to match color that whatever color you get will be lighter when it dries. With a thin, pointed plaster tool work the thick paste into the cracks. If a crack looks gaping and ugly but is still too small to get the paste into, dig a trough along the length of it with your plaster tool, gouging out clay and epoxy. Then fill with the water-putty paste. Once water putty has hardened it is practically impossible to remove from the porous surface of the fired clay without scraping some clay off with it. So work carefully and cleanly.

To build up forms with water putty, use a sable watercolor brush dipped in water to add the paste bit by bit. Keep smoothing and blending the form as you build, and keep dipping the brush in water to clean it so the hairs won't get clogged with the thick paste. Once hard, the putty can be sanded with ordinary sandpaper. This will blend the material into the surrounding clay. The clay, too, can be sanded if you want to get rid of surface imperfections.

PINNING

A typical break in a standing figure occurs at its weakest point, the ankles. Gluing this kind of break with epoxy won't prevent the ankles from snapping again higher up or further down. The best way to repair an ankle break is by inserting a pin in the supporting leg. The pin can be any

rigid iron or copper rod of a sufficiently small diameter to fit into the leg without having to drill too big a hole.

To drill the hole for the pin, lay the figure down on a pillow or cushion. With an electric drill fitted with a masonry (carbide-tipped) bit, gently drill upward from the break into the leg. Fired terracotta doesn't drill that easily, so don't drill any farther than is strictly necessary; you needn't go as high as the bit will allow. Drill a corresponding hole in the other part of the broken piece, from the break down into the foot. Cut the rod to the proper length, a fraction shorter than the combined length of the holes. If the rod is thin it can be cut with a wire cutter; if it is thick you may need a hacksaw to cut it with. Dip one end of the pin in epoxy and insert it into the foot. Hold the figure upside down and pour a little epoxy into the hole in the leg so that it runs well down into the cavity. Put more epoxy on the break area. Now lower the figure down over the pin, so that the pin slides up inside the leg. Work the two parts together until the seam is true and tight. Hold in place for a few minutes until the epoxy sets, then quickly, while it's still tacky, remove the excess glue that has oozed out of the seam. If the seam is very noticeable you may want to dig it out as described above under "Patching and Reconstruction" and fill it with water putty.

PATINING

Lucchesi uses a unique combination of imagination and resourcefulness in patining his terracottas. The major ingredient in his patina solution is liquid wax, the kind sold in supermarkets for use on wood floors. For color he adds water- or alcohol-soluble aniline dyes, dry colors from the hardware store, or ordinary shoe polish. He mixes the coloring agent into the wax, testing the color on a part of the sculpture where it won't show, such as the underside of the base. When the color is right, he applies the liquid with a large housepainter's brush. The color can be darkened with cake shoe polish even after the wax has dried—about 5 minutes. Lucchesi also rubs shoe polish into the surface to highlight the forms.

Liquid wax produces a high-gloss surface. For a more matte surface the wax can be diluted with wood alcohol. Or, if you're brave, you can do what Lucchesi does: he brushes on the liquid wax, then before it dries he takes the dirtiest rags and brushes in the studio and shakes and slaps them all over the sculpture. The tiny dust and clay particles stick fast to the tacky wax, producing a soft, textured, mottled patina almost like that of bronze. If you try this, for the best results make sure that your rags and brushes are really dirty and full of dry clay. The good thing about a wax patina is that it can be removed at any time with alcohol. So if you make a mistake or don't like the patina you can try again.

MOUNTING

You can have your sculpture professionally mounted on a base or you can mount it yourself. Or it may not require mounting at all. Sculpture bases are available in Micarta, Formica, plastic, solid woods, wood veneers, and marble. If you make your own, a piece of pine 1½" (3.8 cm) thick and painted with a semigloss latex enamel black paint makes a fine base. Some of Lucchesi's favorite bases are the teak cutting boards sold in wood craft stores. They come in various sizes, rectangular or round. Sometimes they have a groove all around near the edges, in which case Lucchesi simply turns them over and uses the underside as the top of his base. To attach the sculpture to the base just apply a few dabs of epoxy. For more complicated mountings a rod may be necessary to hold the sculpture securely on the base. If so simply drill a hole in the sculpture with a masonry bit, another in the base with a wood bit, and cut a rod to the correct length. Dab epoxy in both holes as well as on whatever portions of the piece will come into contact with the base. Place one end of the rod into the base and lower the sculpture down over the rod, working it around until you find the most effective position. If you glue your sculpture onto

a painted base, either scrape off the paint where you're going to place your epoxy or when you paint leave an area free. Otherwise the epoxy could pull off a patch of paint if the bond were to be put under pressure.

A word of caution if you do your own mounting with epoxy: never pick up the sculpture in such a way as to exert undue pressure on the bond. It will hold firm to the clay but in so doing it can rip a whole layer right off the piece. In other words, any time you have to pick up the sculpture and carry it from place to place, make sure you pick it up by the base and hold it upright, not tilted. And if the piece is top-heavy and attached to the base by small areas only—such as the feet, or the legs of a chair—be doubly cautious as the slightest tilt is magnified by the top weight. In this case it's wise to keep one hand on the base and the other on the piece, so that you're holding both parts as you lift and carry it.

ORTON PYROMETRIC CONES

SENIOR CONE NUMBER	FINAL TEMPERATURE REQUIRED	
	@ 108° F/hr.*	@ 270° F/hr.*
022	1085° F	1112° F
021	1116	1137
020	1157	1175
019	1234	1261
018	1285	1323
017	1341	1377
016	1407	1458
015	1454	1479
014	1533	1540
013	1596	1566
012	1591	1623
011	1627	1641
010	1629	1641
09	1679	1693
08	1733	1751
07	1783	1803
06	1816	1830
05	1888	1915
04	1922	1940
03	1987	2014
02	2014	2048
01	2043	2079
1	2077	2109
2	2088	2124
3	2106	2134
4	2134	2167
5	2151	2185
6	2194	2232
7	2219	2264
8	2257	2305

*Final temperature for cone maturity depends on rate of temperature increase within kiln during final 300-400° of firing.

Table courtesy of the Edward Orton, Jr. Ceramic Foundation, reproduced from the Skutt kiln instruction booklet with permission of Skutt Ceramic Products

QUICK REFERENCE CHART

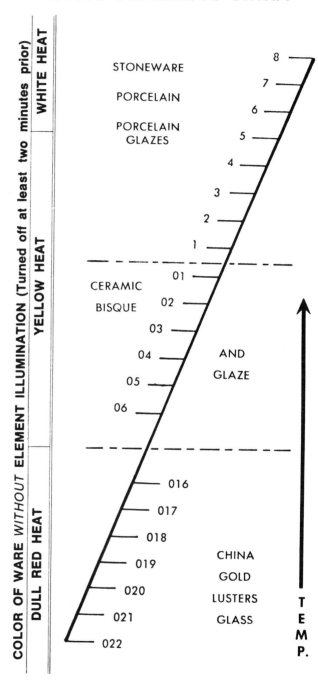

SUPPLIERS

The suppliers listed here are all in the New York metropolitan area. For suppliers in other parts of the country consult your local Yellow Pages under "Pottery Equipment and Supplies," "Sculptors," and "Sculptors' Equipment and Supplies."

CERAMIC CLAYS
These suppliers all have mail-order delivery.

Sculpture Associates, Ltd.
114 East 25 Street
New York, N.Y. 10010

Sculpture House
38 East 30 Street
New York, N.Y. 10016

Stewart Clay Company, Inc.
133 Mulberry Street
New York, N.Y. 10013

Jack D. Wolfe Company, Inc.
724 Meeker Avenue
Brooklyn, New York 11222

SCULPTURE TOOLS
All of the above, plus:

Baldwin Pottery, Inc.
540 La Guardia Place
New York, N.Y. 10012

Sculpture Services
9 East 19 Street
New York, N.Y. 10003

as well as most art supply stores

ELECTRIC KILNS

Baldwin Pottery, Inc.
540 La Guardia Place
New York, N.Y. 10012
California (gas), Cress, Econo-Kiln, Jen-Ken, Paragon, and Skutt kilns

Sculpture House
38 East 30 Street
New York, N.Y. 10016
Norman kilns

Stewart Clay Company, Inc.
133 Mulberry Street
New York, N.Y. 10013
Craftkilns

FIRING SERVICES
For firing opportunities in your area consult your local pottery suppliers, craft schools or groups, or art departments of schools. It may take a bit of asking around before you find someone willing to fire your work for you. In the New York area two well-established firing services are:

Baldwin Pottery, Inc.
540 La Guardia Place
New York, N.Y. 10012

Studio Workshop
3 West 18 Street
New York, N.Y. 10010

CASTING AND MOUNTING
You may want to have your terracotta sculpture professionally mounted on sculpture bases; you may also want to have copies, or casts, made. Both services are available from the following:

Gino Giannaccini Sculpture Casting
120 St. Mark's Place
New York, N.Y. 10009

Rocca-Noto Sculpture Studio, Inc.
18 West 22 Street
New York, N.Y. 10010

Sculpture Associates Ltd.
114 East 25 Street
New York, N.Y. 10010

Sculpture Casting
155 Chrystie Street
New York, N.Y. 10002

Sculpture House
38 East 30 Street
New York, N.Y. 10016

Sculpture Services
9 East 19 Street
New York, N.Y. 10003

BRONZE CASTING FOUNDRIES
The ultimate, and most expensive, of course is a bronze cast. You can have your terracotta cast into bronze at any of the following:

Excalibur Bronze Sculpture Foundry
49 Bleeker Street
New York, N.Y. 10010

Joel Meisner & Company, Inc.
120 Fairchild Avenue
Plainview, New York 11803

Modern Art Foundry, Inc.
18–70 41st Street
Long Island City, New York 11105

Roman Bronze Works, Inc.
96–18 43rd Avenue
Corona, Queens
New York 11368

KILN MANUFACTURERS
Here are the major manufacturers of electric kilns in the U.S. They will be able to tell you where their dealers are in your area.

Cress Manufacturing Company
1718 Floradale Avenue
South El Monte, California 91733

Duncan Kiln and Equipment
Division of Duncan Enterprises
P.O. Box 7609
Fresno, California 93727

Jenkins Wholesale Company
(Jen-Ken Kiln)
4569 Samuel
Sarasota, Florida 33577

L & L Manufacturing Company
(Econo-Kiln)
142 Conchester Road
Chester, Pennsylvania 19016

Norman Kilns
38 Buckley Avenue
Portchester, New York 10573

Paragon Industries
P.O. Box 10133
Dallas, Texas 75207

Skutt Ceramic Products
2618 S.E. Steele Street
Portland, Oregon 97202

Stewart Clay Company, Inc.
(Craftkiln)
133 Mulberry Street
New York, N.Y. 10013

For gas kilns write to:
California Kiln Company
3036 Oak Street
Santa Ana, California 92707

INDEX

Edited by Sarah Bodine
Designed by Bob Fillie
Set in 11 pt. Helvetica Light by Gerard Associates/Phototypesetting, Inc.
Printed by Halliday Lithograph Corp.
Bound by A. Horowitz and Sons

Terracotta—Italian for "baked earth"—is one of the fastest, most direct, and inexpensive mediums available to the sculptor. Since the Renaissance, terracotta has been a favorite material for sculptors' small working models because, being fired not cast, it can be modeled with an enormous degree of freedom and inventiveness. For the sculptor working in clay who feels restricted by the demands of casting his work, terracotta offers a liberating experience both in technique and in the possibilities of expression. And for the beginner it offers a medium that is at once easy to work with and satisfying in that the finished piece is really the finished piece and not merely the first step in the casting process.

Now, for the first time, the undisputed modern master of terracotta technique shares his unique approach in book form. In demonstration sequences that allow the reader to follow every step, accompanied by clear explanatory text, Bruno Lucchesi shows the reader how to work with terracotta, from modeling the human form to firing and finishing. He first introduces the reader to the tools and materials used in terracotta sculpture, then explains the basic principles of working with terracotta clay, with special emphasis on how to construct pieces so they will fire successfully. Next, in a series of step-by-step demonstrations, Lucchesi shows how to approach a variety of sculptures, each with its own requirements: a standing figure with a hollow torso; a hollow-torso figure seated on a chair made from wire and plaster of paris; a figure reclining on cushions built over a foam-rubber core; bas-relief; a lifesize portrait head showing how to model the features of the face and how to treat hair; and a female torso and a male torso, each running the gamut of modeling and texturing techniques and showing the differences in surface anatomy.

Following the demonstrations, a chapter on firing and finishing explains how to prepare pieces for firing and how to fire, as well as how to repair (if necessary) and finish terracotta sculpture. And to complete the information, a comprehensive suppliers list offers a full selection of mail-order sculpture supply houses as well as sources for kilns and sculpture services such as firing, casting, and mounting.